Myth, Magic, and Metaphor

A Journey Into the Heart of Creativity

Myth, Magic, and Metaphor

A Journey Into the Heart of Creativity

Patricia Daly-Lipe, Ph.D.

Myth Magic and Metaphor

Cover painting by Patricia Daly-Lipe, Ph.D.

Untitled c. 1925 Daly Highleyman, page 22

Untitled c. 1920 Daly Highleyman, page 24

Still Life with GingerJar Paul Cézanne, page 111

Nude Descending a Staircase Marcel Duchamp, page 116

© 2005 Artists Rights Society (ARS), New York / ADAGP, Paris / Succession Marcel Duchamp

Girl Before a Mirror, P. Picasso, 1932, page 121

Deerhaven Lake © 2005 Ed Knepley, page 137

Dogwood Lane © 2004 Ed Knepley, page 202

First Edition – Published 1999 by 1st Books Library

ISBN - 0-97449-385-6 LCCN: 2003112753

Second Edition - Published by 2001 by 1st Books Library

ISBN: 1-58500-337-9

Third Edition - Published in 2005 by JADA Press
ISBN: 097641-158X
LCCN: 2005928396

Fourth Edition - Expanded and Revised –
Published in 2015, by ROCKIT PRESS

ISBN: 978-0-9908011-7-7 Hardcover

ISBN: 978-0-9908011-8-4 Paperback

ISBN: 978-0-9908011-9-1 Electronic Book

Printed in the United States of America

ROCKIT PRESS

About the Book

*M*yth, Magic, & Metaphor puts together a creative writing classroom scenario. The idea is to awaken the aesthetic sense and the creative muse who lurks within us all. The method is multisensory, interdisciplinary, and holistic. Philosophy, art, music, and linguistics are some of the disciplines used. The goal is to have the reader recognize and enjoy the process. It asks for the readers to experience the sense of wonder they knew as children, to use their imagination, to feel and absorb the world around them; to listen, not just hear and to see, not just look look. The goal is to become intoxicated with life. The tool is the heart. The medium is words.

"They say that the human mind, once stretched to a new idea, never returns to its original shape." (Georgi Lozanov). Our hope is that this little tome will reshape a few minds.

"*'Myth, Magic, & Metaphor'* is luminous with oracular wisdom about the nature and sources of creativity. From first page to last, this book will inspire you to be inspired."

Richard Lederer, author of *The Miracle of Language, Crazy English, The Play of Words,* and many other "Linguistic Treasures."

Acknowledgements

*T*his book owes its existence to my students. I do not believe we can learn *how to* write. We do, however, learn *as* we write. In the same vein, I did not *teach* my students. I provided a blueprint, an impetus, and an environment for them to achieve their goal. In turn, their interest and enthusiasm taught and inspired me.

A thank you is also given to all the readers who have, since the book's first publication in 1999, written to offer their appreciation and gratitude as well as to the people who have asked me to give talks about our theme: creativity.

This new edition is an expansion of the original, incoporating new ideas plus some of my own creative ventures in writing. I am deeply indebted to the editing skill of Shauna Shapiro Jackson. Simply amazing!

Last but not least, I remain indebted to and appreciative of the patience, encouragement and left-brained, fact finding skill of my dear husband Steele Lipe, M. D. It was also he who incorporated the photographs into the text, lined up the paragraphs and created the format. Thank you to the love of my life!

Table of Contents

A Journey Into the Heart of Creativity

"The more faithfully you listen to the voices within you, the better you hear what is sounding outside."

Dag Hammarskjöld, Secretary General of the United Nations

We do not write in order to be understood; we write in order to understand.

C. Day Lewis

[It is] out of what I don't know that I begin to write.

Toni Morrison

We need more poetry that reveals what the heart is ready to recognize.

Joseph Campbell

Inspiration is more important than knowledge.

Albert Einstein

Nobody can advise and help you, nobody. There is only one single means. Go inside yourself. Discover the motive that bids you [to] write; examine whether it sends its roots down to the deepest places of your heart.

Rainer Maria Rilke

Introduction

*No matter what our attempts to inform, it is our ability to inspire
that will turn the tides.*

Jan Phillips, *Marry Your Muse*

*I*n this post 9/11 era, despite our differences in opinion, race, creed, or
nationality, let us not lose sight of one fact. We are all human beings.
And as human beings, we share this planet, a small blue ball spinning
around within a gigantic universe (which may be a small dot among
many universes). The scope of our environment, going to the stars and
beyond, is immeasurable, but within each one of us lurks a bright light
waiting to be released. The light has no limits. It has no structure. It is
called creativity.

I call creativity the muse who lurks within us all. She wants and
waits for us to recognize her, to free her, to allow her to express herself.
She is a gift that binds us as mortals to something much bigger.

Organization, rules, limits of all sorts are taking over our psyches.
The idea of no rules and the ambiguity of intuition are frightening
concepts to so many of us today. But there is a new word that is catching
on and communicating to us on many levels. The word is 'globalization'
and it implies extensive opportunities for worldwide development,
achievement and collaboration. Globalization is the result of a historical
process. It reflects both human innovations and technological progress.
The good news is that globalization also begs for creativity. There is
dynamism to creativity; an enthusiasm which is generated deep within

the individual. Creativity empowers a release of tension. For this reason alone, it is essential.

This book was originally written with the encouragement of Richard Lederer in 1999. So much has changed since then. In this book, I encourage an interdisciplinary approach to awaken the creative muse within all of us. The readers' recognition of their own creativity can be expressed in many disciplines, from the creative arts to science, but my main focus is writing. Each of us has a story. We relate to the world in as many billions of ways as there are humans on this planet.

A little aside about Richard Lederer. This is what he said a few years ago when asked about his work:

> *Not long ago, I visited a nearby progressive elementary school and chatted for about forty-five minutes with the sixth graders about the joys of language and the writing life. One of the boys in the class asked me, "Dr. Lederer, where do you get your ideas for your books?"*
>
> *Ever since I became a writer, I had found that question the most difficult to answer and had only recently come up with an analogy that I thought would satisfy both my audience and me. Pouncing on the opportunity to unveil my spanking new explanation, I countered with, "Where does the spider get its web?"*
>
> *The idea, of course, was that the spider is not aware how it spins out its intricate and beautiful patterns with the silky material that is simply a natural part of itself. Asking a writer to account for the genesis of his or her ideas is as futile as asking a spider the source of its web and method of its construction.*

The young man, in response to my question, appeared thoughtful for a moment. Then he looked me squarely in the eye and shot right back, "The spider gets its web from its butt!"

I checked out the boy's assertion, and, sure enough, spiders do produce their silk from glands located in the posteriors. The glands open through tiny spinnerets located at the hind end of the abdomen. Well, it may be that for lo these many years I've been talking and writing through my butt, but that doesn't stop me from being an unrepentant verbivore.

Whether you are a scientist, a technician, a doctor, a housewife or an artist, you have something unique to say – no matter where it comes from! So let the words flow. Allow them to topple, trip, and stumble. Play. Enjoy. Explore. Theodor Seuss Geisel, better known as Dr. Seuss, said, "Adults are obsolete children." Youth is not a time of life. Youth is a state of mind. Let the child come out; he or she is in there just waiting to be released again. As a child, remember how you tumbled through life. No condemning. No judgments. Free.

Try out the words and let them try you out. The words are not demons. Let them – and believe me, they will – take over. Sit back, laugh, cry as the words flow. Watch as the imaginary becomes the actual. Experience the mystery, the magic of seeing, written on a page, words you never could have imagined writing. Talk about therapy! Vincent Scully, the great Yale architectural historian said it best. "Put the right words together with the visual facts so that all of a sudden sparks fly and a new skill is born – the ability to see."

The key to writing is writing. Phyllis Whitney said, "I think with a pencil." Your real tool is your mind. Your medium is words.

Hélène Cixous, Professor at the University of Paris VIII and a remarkable author, wrote in *Coming To Writing*:

> *"In the beginning, I adored. What I adored was human. Not persons; not totalities, not defined and named beings. But signs. Flashes of being that glanced off me, kindling me. Lightening-like bursts that came to me: Look! I blazed up. And the sign withdrew. Vanished. While I burned on and consumed myself wholly. What had reached me, so powerfully cast from a human body, was Beauty…. A desire was seeking its home. I was that desire. I was the question. The question with this strange destiny; to seek, to pursue the answers that will appease it…."*

Problematically, in that unsettled, indefinable way the creative muse works, Mlle Cixous concedes (with a chuckle, I assume), "Yet what misfortune if the question should happen to meet its answer!"

It is, after all, the journey not the destination which brings its rewards. Writing opens doors, doors which may lead not to answers, but to more questions. Writing is a way of introducing wonder and surprise to ourselves. To use Mlle Cixous' words, "My writing watches. Eyes closed."

Or enjoy what Theodor Seuss Geisel (aka Dr. Seuss) wrote:

> *"I like nonsense.*
> *It wakes up the brain cells.*
> *Fantasy is a necessary ingredient in living.*
> *It's a way of looking at life through the wrong end of a telescope.*
> *Which is what I do.*
> *And that enables you to laugh at life's realities."*

That mysterious faculty, which some call genius, cannot be 'taught'. But it can be discovered.

Introduction

Look for the extra-ordinary in the ordinary. Go a step further and take the 'order' out of 'ordinary'. For example, you might remember some incident which may have seemed commonplace at the time but which, upon reflection, you found significant. Write about the incident and as you write, let the words take control. You may find that the words move up from a simple description to a plateau of revelation. Writing does that. It is a combination of intuition, desire, and open-mindedness combined with hard work, long hours, and a solid foundation which allow a writer to write and to write creatively. It is my hope this book will assist you, my reader, to become the writer. Enjoy and discover your own creative muse.

1

Words

In the beginning was the Word;
and the Word was with God;
and the Word was God.

(The Gospel According to John)

The word is a sign or symbol of the
impressions or affections of the soul.

Aristotle

*L*anguage contains everything from history, to sociology, economics, philosophy, religious thought, even stories. Think of the word 'community' as meaning 'common unity'. Language has been used and abused throughout history but it still reflects human destiny and reveals all that is known of life itself. Language is ACTIVE; language USES us! Especially the English language. Listen to Richard Lederer on this score:

> *Let's face it – English is a crazy language. There is no egg in egg-*
> *plant nor ham in hamburger; neither apple nor pine in pineapple.*
> *English muffins weren't invented in England or French fries in*
> *France. Sweetmeats are candies while sweetbreads, which aren't*
> *sweet, are meat. We take English for granted. But if we explore its*
> *paradoxes, we find that quicksand can work slowly, boxing rings*
> *are square and a guinea pig is neither from Guinea nor is it a pig.*

And why is it that writers write but fingers don't fing, grocers don't groce and hammers don't ham? If the plural of tooth is teeth, why isn't the plural of booth beeth? One goose, 2 geese. So one moose, 2 meese?

If teachers taught, why didn't preachers praught? If a vegetarian eats vegetables, what does a humanitarian eat?

You have to marvel at the unique lunacy of a language in which your house can burn up as it burns down, in which you fill in a form by filling it out and in which an alarm goes off by going on. English was invented by people, not computers, and it reflects the creativity of the human race (which, of course, isn't a race at all). That is why, when the stars are out, they are visible, but when the lights are out, they are invisible.

"The genius of democracies," wrote Alex de Toqueville in 1840, "is seen not only in the great number of new words introduced but even more in the new ideas they express." To which, in 1936, Willa Cather might be said to reply, "Give the people a new word and they think they have a new fact." Well, quite aside from Mr. Lederer's funny, but sadly accurate insight on English, let us take a more serious look and explore the facts behind language as suggested by Miss Cather.

Words–so innocent and powerless as they are, as standing in a dictionary, how potent for good and evil they become in the hands of one who knows how to combine them.

Nathaniel Hawthorne

As Hawthorne points out, words, though seemingly benign, have power. While the spoken and written word can be used to create beauty and value, they can also have a negative effect on the world and humanity if not chosen wisely. One vile word can hurt a person. A sentence can do

more damage. It can demean and devalue a person or group of people, induce embarrassment and even shame. Groups of words can be repeated orally or in art (advertising, film, music), and turned into propaganda in order to enforce an agenda. That propaganda can result in enormous danger as evidenced by the Nazi's success in using propaganda to build anti-Semitism in Germany in order to accomplish their ultimate goal of genocide. Today, we have social media "memes" – the repeated use of words, both oral and written, that can spread quickly and become adopted as a general "truth" in society. With the internet, these memes can spread throughout the world extremely rapidly. In other words, communicated language causes others to think and, often, believe.

According to Webster's Dictionary, 'to think' means "to have the mind occupied on some subject; to judge, to intend, to imagine, to consider." It is a transitive verb which means that thinking requires an object. As Paul Brunton stated in *The Hidden Teaching Beyond Yoga*, "[W]e cannot see any object without *thinking* of it as being seen. If it is to exist for us at all, it must exist as something that is perceived." And he takes his case a step further. "We perceive the object because we think it; we do not think the object because we perceive it." First the thought, then the thing.

> *Intuitively I felt that the functions of language were of a duel nature – that of suggestion and that of communication, and I attributed to the poetic use of words a superiority over that of everyday communication.*
>
> Eugene Jolas, *Man from Babel*

In other words, search for the metaphysical essence of the word. (For an in-depth and fascinating discussion of language and the origin of language verses thought, read *Thought and Language* by Lev Vygotsky in the 'newly revised' edition by Alex Kozulin).

The conclusion of this mini-debate is this. Our very existence as a member of the human race is defined by thought. Whether thought or the object perceived comes first is for you to decide. (For the blind, "perception" can be the sensation of touching or smelling.) Nevertheless, both thought and perception underlie our ability to communicate, and communication is directly related to our humanity, which is essentially social. We co-exist on this planet, for better or worse and we communicate with words.

> *Man's mind enables him to form concepts, use language, build so-cieties and cultures; above all, it enables him to work in intellectual community (where) ... the emotional and intellectual life of each man is sustained by his unity with others.*
>
> J. Bronowski's review of Teilhard de Chardin's *The Future of Man*

Life is a journey. The base of the word 'journey', is *jour* meaning day (from the French). Language reveals the journey, the daily experiences which define life. To be more precise, language reveals our own or some other person's observation. The testimony of the senses leads us to accept multiplicity and change; every moment we see or observe a new image or mental observation of what we call life. A smell, a sound, a touch, each sense stimulates an entire storehouse of memory. These moments are what Friedrich Nietzsche called the "creative truths."

However, language is more than name-calling. Toni Morrison said in her acceptance speech for the Nobel Prize for Literature in 1993, "The vitality of language lies in its ability to limn the actual, imaged, and possible lives of its speakers, readers, and writers It arcs toward the place where meaning may lie."

We will explore what the "meaning" or the "creative truths" are as the chapters progress, but let it be established here that history is

not defined by dates and and names. History is someone's personal perspective, someone's experience in a particular time in the development (or decay) of the human race. It can be said that historical fiction is a combination of two nouns. The fiction being what is inside your or the protagonist's mind at the time of an event and history the time and event. Since history is recorded by people, and since all people are prone to their own perspective on what they see, then it might be said that all history is fiction.

> *Novels arise out of the shortcomings of history.*
> F. von Hardenberg, *Later Novalis Fragmente und Studien,* (1799–1800)

Let us -return to another history, the history of words. Open a dictionary and explore. Mark Twain joked, "I have studied [a dictionary] often, but I never could dicover the plot." Every word in the dictionary, however, has a plot of its own, its etymology. We understand that individual words, especially nouns, contain history, sociology, economics, politics, and/or drama, keeping in mind that they change and evolve with each generation and sometimes come and go and return in a new context. It can be like a complex maze to attempt to follow the historical trail of a word. But let us begin anyway and choose a word that depicts the essence of what is called 'life'. It is a word which is not static. Instead this word reflects the flow which is life. The word is inspiration. The etymology of inspiration is the Latin word, *inspiratus,* past participle of *inspirare* meaning to blow or breathe upon. Thus, if we follow the evolutionary/etymological sequence through, creativity refers to the life-giving force: breath. When a baby comes out of the womb, he breathes for the first time on his own and begins life as we know it. Analogous to this birthing is the creative process represented by the writer, the painter, the musician or the dancer. Isadora Duncan, the great innovative interpreter of dance at the

turn of the twentieth century, spoke of the "state of complete suspense" which proceeds the so-called spontaneous creative activity (dance or music or painting or writing). This non-verbal excitement, dreamlike, vague, ambiguous comes *before* the creative act or action. Stephen Spender, English poet and critic, expressed this time as "a dim cloud of an idea which I feel must be condensed into a shower of words."

> *All writing requires at least some measure of trance-like state: the*
> *writer must summon out of nonexistence some character, some*
> *scene, and he must focus that imaginary scene in his mind until he*
> *sees it vividly as, in another state, he would see the typewriter or*
> *cluttered desk in front of him…. But at times something happens.*
> *A demon takes over … and the imagery becomes real.*
>
> <div align="right">John Gardner</div>

Inspiration is the stimulus to creative thought or action. In theology, *inspiritus* is a divine influence upon human beings resulting in writing, as in the Scriptures, or in action, as with a Saint. There are steps to achieving inspiration according to the Buddha, inspiration being the state of Nirvana. However, the inspiration itself is "beyond words."

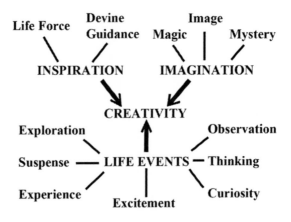

Imagination and inspiration are two elements intrinsic to the concept of creativity. According to the Buddha, "as the mind returns to its natural state of integrity and non-duality, it ceases to clutch at experience with the symbols of discursive thought. It simply perceives without words or concepts." Then, once it has perceived 'the truth,' the Buddha tells us, the mind reverts to discourse and the written word. (A note should be made here about the Buddha. To quote Joseph Campbell, "the reference to the life of the Buddha is quite secondary. The accent in Hinduism and Buddhism is the relevance of the symbolic forms to your own life. You understand these things inward to yourself.") Following the Buddhist concept, you could say the 'truth' comes as a sudden flash of understanding. It is outside of time and space. It is beyond words. Once the mind has perceived this 'truth' (Nirvana), it reverts back to reality (as we know it) and to discourse and the written word.

> *Inspiration may be a form of superconsciousness, or perhaps of subconsciousness – I wouldn't know. But I am sure it is the antithesis of self-conscious.*
>
> Aaron Copeland

Inspiration, we shall see as the chapters progress, can be said to be the alluring voice of creativity.

> *Be but thy inspiration given,*
> *No matter though what danger sought,*
> *I'll fathom hell or climb to heaven,*
> *And yet esteem that cheap which love has bought.*
> *Fame cannot tempt the bard*
> *Who's famous with his God,*
> *Nor laurel him reward*
> *Who has his maker's nod.*
>
> Henry David Thoreau, *Inspiration*

Be beguiled by your own unconscious mind. Allow the door to your unconscious to open, then watch what flows out on the paper before you and read the words in awe.

> *It is our idleness,*
> *in our dreams,*
> *that the submerged*
> *truth sometimes*
> *comes to the top.*
>
> Virginia Woolf

Take the word 'idleness' and respect it. Idleness does not connote laziness. It is our time to be silent and one with the world around us. The silence is golden when absorbed.

> *A man should learn to detect and watch that gleam of light which flashes across his mind from within, more than the lustre of the firmament of bards and sages.*
>
> Ralph Waldo Emerson, *Self-Reliance*

> *I am enough of an artist to draw freely upon my imagination. Imagination is more important than knowledge. Knowledge is limited. Imagination encircles the world.*
>
> Albert Einstein

Let your imagination blossom and tap into your subconscious. What you did not know that you knew will suddenly come forth and you will begin to write and to write well. *"A man never rises so high as when he knows not whither he is going."* (Oliver Cromwell) Isabel Illende, when she wrote the poignant novel/diary to her daughter, *Paula,* explaining herself, her past, her present, and her life as a writer, counseled that the writer must "believe the unbelievable."

Once again, to quote the first great philosopher born on American soil, Ralph Waldo Emerson: "We but half express ourselves, and are ashamed of that divine idea which each of us represents." First, believe in yourself. Second, as author Lucia St. Clair Robson wrote, make connections; always make connections. Be aware of what you see, what you feel, what you smell. Sink into the scene. Be ready for and allow "unscheduled flights of fancy!"

> *God guard me from those thoughts men think*
> *In the mind alone,*
> *He that sings a lasting song*
> *Thinks in a marrow bone ...*
> *I pray—for fashion's word is out*
> *And Prayer comes round again –*
> *That I may seem though I die old*
> *A foolish, passionate man*
>
> William Butler Yeats

To create is to give birth, the act of bringing forth something new. All animals have the ability to give birth. But it is also man's unique ability to produce creative art. "Whether the instrument of the words she use, or pencil pregnant with ethereal hues" which "demands the service of a mind and heart." (Wordsworth)

As far as we know, we as humans are the only animals conscious of being conscious. Not satisfied with just accepting what happens to us, we naturally inspect and challenge every move, every thought. Philosophers from Heraclitus to Plato, from the Buddha to Nietzsche have catechized and questioned the creative process. Friedrich Nietzsche, in *Composition on Thus Spoke Zarathustra,* wrote about the notion of revelation or the creation of a new idea. A new idea, he said,

is something "profoundly convulsive and disturbing" which "suddenly becomes visible and audible with indescribable definiteness and exactness … a thought flashes out like lightning, inevitably without hesitation – I have never had any choice about it."

James Joyce spoke of an "aesthetic arrest" or "stasis." It is the point where you are aware of the silence within the very center of activity both in this world and out of the universe. It is there, he says (marrying the East with the West in thought) that "the mind is arrested and raised above desire and loathing" and "the world is recognized as a revelation sufficient in itself." For Joyce, even (and most often) the most trivial things could be invested with "epiphanies." In *Portrait Of An Artist As A Young Man*, the protagonist Stephen Dedalus says, the 'soul' or 'whatness' of an object or a gesture or a phrase "leaps to us from the vestment of its appearance."

Plato, arguably one of the greatest of all Western philosophers, 470–399 BC, using the voice of Socrates (who, like the Buddha, never wrote anything down and could represent more than one philosopher or thinker), stated that for art (by this we encompass any of the art forms including creative writing) to be truly noble, it must reveal "something of that essence which is eternal…."

Whether understood from an Eastern perspective or a Western conviction, belief, or philosophy, it must be concluded there is something mysterious about the concept and the process of creativity. Isn't it exciting to think that you, the writer, are actively involved in this, the very essence of life itself? To quote Nietzsche again, "For art to exist, or any sort of aesthetic activity or perception to exist, a certain psychological precondition is indispensable: *intoxication*." [The italic emphasis is my enthusiasm being expressed visually.]

We have come a long way from the initial search into the source of creativity and even further from the search into the meaning and use of our medium: words. However, I hope my reader will consider the various arguments and opinions and continue to accept little and question all and everything. It is a healthy exercise and, at the very least, will prevent atrophy of the brain.

2

Creativity

*Consider the thought elements in perception
and the perceptual elements in thought.*

*T*he word 'creativity' (be it expressed through myth or a story) seems to be an anachronism to the modern era of high technology with its computer networks, fiberoptics, complex and intrinsically specialized data bases, all of which require logical thought processes, a definite rationale, facts, and information. In fact. this digital technology has been proven to leave a mark on your brain. It is, according to Susan Greenfield, (British neuroscientist and author of 'Mind Change, How Digital Technologies are Leaving Their Mark On Our Brains') "an existential crisis." Consider the immediate reaction to video games. No thinking. No judgment. Reaction in the moment. So in the brain of the child playing this game, there is a kind of atrophy of development. Emotion, is lost. Take a child away from the game and lead him or her outside and watch as the child laughs and smiles and plays as the snowflakes drop down. No laughs or smiles in video games! In this environment of digital technology, it is difficult to justify, much less explain, the need – actually the necessity – to take time out, to 'listen' to the silence, to gaze in wonderment at a leaf or a flicker of light, to be quiet enough to be startled.

*I have a need of silence and of stars,
Too much is said too loudly. I am dazed.*

The silken sound of whirled infinity
Is lost in voices shouting to be heard….

William Alexander Percy wrote this poem entitiled "Home" when he was in New york City. Unlike noisy New York, 'home' for him was the quiet countryside in Mississippi. Or take the words of Henry David Thoreau, written in his journal in 1841: *A slight sound at evening lifts me up by the ears, and makes life seem inexpressibly serene and grand. It may be in Uranus, or it may be in the shutter.* Packing Uranus and shutter together, the point is his taking the time to listen; taking the jouney into the mind, his mind.

To be *transported* can happen in silence. But it is avoided in today's rushing world where mobile phones distract from the sound of wind, the cool breeze, the smell of someone's cooking, the view of the sun descending. And fear of spontaneity, nonconformity, irrationality, and the unconscious and subconscious mind has been encouraged by the gurus of computer literacy. But, admit it or not, even they had, at one time, to wean themselves from the so-called mystical traditions, be they religious, philosophical, or even folklore.

Tom Robbins cautions, "[T]he mission of the artist in an overtechnologized society [is] to call the old magic back to life." We will talk about magic later; just keep it in the back of your mind for now.

> *Tools and techniques ought to be an extension of consciousness, but they can just as easily be a protection from consciousness. Then the tools become defense mechanisms … specifically against the wider and more complex dimensions of consciousness that we call the unconscious.*
>
> Rollo May, *The Courage to Create*

Why are so many people frightened to not have the answers? Is the world so scary, so demanding, that we cannot take time out, ask the questions and even admit we simply do not know the answers? Is this the era of the "mechanization of the human spirit" as Mr. Jonas called it back in the 1920s in Paris?

Inspiration comes from the roaming of free imagination, but it takes time. *"A time to make time stand still, remembered as a timeless time fulfilled."* This quote was written by Patty Daly, no relation to the author, but same name and a kindred spirit. More about Patty Daly later.

I am writing on my PC computer which has Windows 7, plus many other exciting accessories. I have come to depend on this machine completely for everything from writing to reference, from fax to internet access. Last year, it was attached by a virus (personification in the computer world!). With sheer terror, I ran to my technical guru. "Save my novel," I cried, loosing all sense of decorum and composure. Fortunately he did, but it was at great expense. I lost both time and money. Nevertheless, to benefit from the experience, I translated it as a sign/warning/omen. The real source of creativity was not my computer but ME! Some sick individual was taking great pleasure in sucking out my words one line at a time (the virus even made a sucking sound: "slop, slop, slop") and the hacker didn't even know me! My pleasure had been the process of writing. What was his (or possibly, hers)?

Benjamin Lee Whorf, an American linguistic scientist in the early nineteen hundreds, believed there was no primitive language per se. Contrary to his contemporaries like Rudolf Steiner, Sigmund Freud, and Carl Jung, Whorf maintained that the structure of language one uses directly influences the way one thinks. "[T]he content of thought influences the process of thought … so that generalization about

process becomes impossible without contents being taken into account." Language, according to Whorf, is a "classification and arrangement of the stream of sensory experience which results in a certain world-order, a certain segment of the world that is easily expressible by the type of symbolic means that language employs." By Whorf's definition, there is no room for the non-verbal, dreamlike, spontaneous urge. Clearly his logic is appealing; but that is what it is, rational and logical. The computer acts the same rational way. It is programmed based on logic. However, spontaneity, the creative urge, something 'new' depicted by the artistic mind does not come from the machine or from logical deductions. Nor is creativity confined to the artist; it is also essential to the scientist and to scientific inquiry. "[N]ature is not perfectly rational and does not efficiently fulfill her own longing for perfection." (Friedrich Nietzsche) The scientist, if he is going to discover something absolutely new, must be open to the concepts of inspiration, imagination, and creativity.

> As a human being (the artist) may have many moods and a will and personal aims, but as an artist he is 'man' in a higher sense – he is 'collective man' – one who carries and shapes the unconscious, psychic life of mankind.
>
> Carl Jung

The mind directs the eye's perception. In a picture we see everything which is in that particular place. It we were there, looking, we would see not only what is there, but movement and mood. The latter is rather difficult to define.

Mood differs from individual to individual. It is determined by two factors: the perceivers past experience and the actual place or thing

being perceived. No man is an independent entity living in his own private little world. To be human is to have historical character.

We are victims, so to speak, of our environment. We learn; we cannot help but learn constantly. But not only are we "taking it all in," we are giving it out too. Communication for the human is a necessity. Take the miraculous example of Helen Keller, a deaf, dumb, and blind child groping for a means of becoming one with the world: communication.

Thus with the human, an object does not only refer to another object and so on until the -picture is complete, but the object may be representative or it may be evocative or it may become instrumental. We are now at the base of what is called creativity or the creative force.

André Bréton, author of the *Surrealist Manifesto* (first edition, 1924), felt (perhaps thanks to Sigmund Freud) "the imagination is ... on the point of reclaiming its right."

Bréton defined Surrealism as:

> [P]re-psychic automatism, by which it is intended to express, verbally, in writing, or by other means, the real process of thought. Thought's dictation, in the absence of all control exercised by the reason and outside all aesthetic or moral preoccupation.

Surrealism called up the irrational world of the subconscious to reveal itself through the medium of an art form, be it painting, music, dance or writing. Way back in the fifteenth century, Leonardo da Vinci had already suggested "the possibility of self-revelation through automatic writing." (Paul J. Sachs, *Modern Paintings and Drawings*) A more recent artist, Salvador Dali, is quoted as saying, "I am the first to be surprised and often terrified by the images that I see appear on my canvas."

I wonder as new faces meet
That smile, then pass me by.
I wonder at all life around
The stars, the moon, the sky.

And yet at times I wonder–what
Just wonder what is meant
By wonders that I have wondered
In times long past and spent.

Daly Highleyman

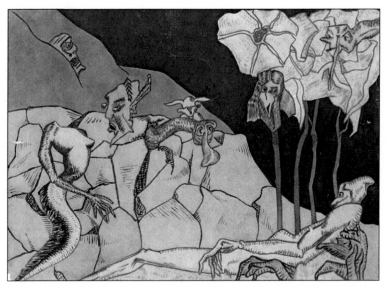

Untitled (c. 1925) Daly Highleyman

In the same period of time as the painting completed above by
my father, artist Joan Miró's art was also spontaneous. Miró's brush
strokes worked on the canvas automatically with little direction from his
conscious mind (like automatic writing). Curved lines and amoeba-like
organisms seem to float in space across his canvas. His paintings can be

called intuitive expressions of his un- or subconscious mind. Mirô said of his paintings:

> *I am attaching more and more importance to the subject matter of my work. To me it seems vital that rich and robust theme should be present to give the spectator an immediate blow between the eyes before a second thought can intervene. In this way poetry pictorially expressed speaks its own language.*

I do believe deep down within our being is the source of creativity and it is that very source which connects to the primal rhythms of the universe. There is no clear boundary between ourselves and the world which we observe. Watching the brilliant orange rays descend into a soft rosy glow at sunset; looking at bare, snow-covered limbs of a tree angling upward toward the clear blue sky; peering through the newly opened petals of a rose; all these pictures capture our imagination. The observer "plays a creative role in the observation." (Robert Hand) So do not think you must have something to say before you put words on paper. Let the insights, visions, ideas happen in the process of writing.

> *Writing is a process in which we discover what lives in us. The writing reveals what is alive…. The deepest satisfaction of writing is precisely that it opens up new spaces within each of us of which we were not aware before we started to write.*
>
> Father Henri Nouwen, (1932–1996) *Reflections*

Look at the following, another picture drawn by my father, Daly Highleyman, in the 1920s. This drawing clearly opened up "new spaces" for him!

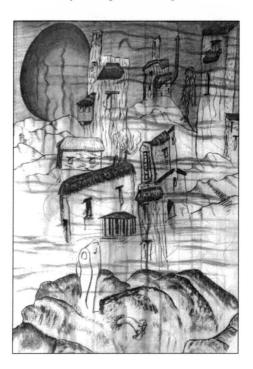

Thus it is not only about what is 'out there' but more important, something about the artist: YOU. Remember Richard Lederer comparing the process of writing to a spider pulling the silk out of its own body. You can never take the writing from the writer and you can never take the writer out of an environment: 'being there.' As Joseph Campbell said, "The entire heavenly realm is within us, but to find it, we have to relate to what's outside."

> [T]he true use for the imaginative faculty of modern times is to give ultimate vivification to facts, to science, and to common lives, endowing them with glows and glories and final illustriousness which belong to every real thing, and to real things only. Without that ultimate vivification – which the poet and other artist alone can give – reality would seem incomplete, and science, democracy, and life itself, finally in vain.

Walt Whitman wrote these strong words. On the one hand, he assumes that there is, in effect, an essence to things which transcends the merely physical aspect, and, on the other, that, for himself as an artist, a tremendous responsibility must be assumed; to share that insight. This is the "calling" of the artist. Whitman wrote the following poem ('Song of the Open Road') to reflect the relationship between the artist and what he sees and internalizes and finally expresses in his art.

Allons! Whoever you are, come travel with me!
Traveling with me, you will find what never tires.
The earth never tires;
The earth is rude, silent, incomprehensible at first -
Nature is rude and incomprehensible at first.
Be not discouraged – keep on – there are divine things, well enveloped;
I swear to you there are divine things more beautiful than words can tell.

Ralph Waldo Emerson, born in Boston in 1803, also wrote about the relationship between man and nature. For Emerson, as well as for all the Transcendentalists (a philosophic movement in New England from 1836–1860 including, besides Emerson, Thoreau, Margaret Fuller, and Bronson Alcott), the Universe was seen as the externalization of the soul. I recommend his essays, 'On Nature', and, 'On Poets', written in 1844. In part, he writes,

Nature is the incarnation of a thought, and turns a thought, again,
as ice becomes water and gas. The world is mind precipitated, and
the volatile essence is forever escaping again into the state of free
thought…. That power which does not respect quantity, which makes
the whole and the particle equal, delegates the smile to the morning,
and distills its essence into every drop of rain. Every moment instructs,
and every object for wisdom is infused into every form.

Let us zoom into the word *wisdom*. Wisdom is not simply defined as accumulated knowledge. Instead, wisdom comes from feeling, a response to our connection with the world around us. "We take from nature what we cannot see," wrote Theodore Roethke (American poet 1908–1963). And advice from Marcel Proust (1871–1922):

> *We do not receive wisdom; we must discover it for ourselves, after a journey through the wilderness, which no one else can make for us, which no one can spare us, for our wisdom is the point of view from which we come at last to view the world.*

Wisdom grows. It grows and develops through our individual experience. Wisdom speaks softly sometimes. But, ultimately, if you listen carefully, you will hear as wisdom speaks from its core: the heart. Never lose that sense of wonder you enjoyed as a child. As a child, time did not count and therein lies the myth we can live by. Remember, we are part of nature.

> *"Nature is not a competition. It doesn't really matter, when you go out, if you don't identify anything. What matters is the feeling heart."*
> (Richard Adams, 1920, British writer)

Consider a storm, a sunset, wild flowers blowing in the breeze, sunlight trickling through the towering tree branches, the surf slashing its foam onto the rocks. Wonder, awe, delight – these are some of our responses.

Language is transitive/transcient. (Latin, *transsire* to go across) Symbols, too, are fluxional. The quality of our imagination is this very flow. We cannot, as creative writers, attach ourselves to fixed objects. We must transcend the items and objects and allow the mystery to enter our consciousness. "Nothing is at last sacred but the integrity of your own mind." (Emerson) It is this very mystery, this inward subconscious level

of thought, which leads us to use symbols. We need symbols. Perhaps it is true what the Eastern mystics say: Nature follows man.

Start writing keeping this Indian adage in mind: "All this struggling to learn, when all we have to do is remember." Widen your i'magi'nation and find the magic. That is your assignment.

3

There Are No Rules

… but, of course, art didn't have laws…. That was
what made art better than life. Or, if not superior,
at least more interesting

<div align="right">

Tom Robbins, *'skinny legs and all'*

</div>

One of the first things I tell my class of potential novelists and
poets is, "There are no rules." Writing comes from the heart.
The creative muse lurks within us one and all. Antoine de St. Exupéry,
pilot and author of *The Little Prince*, wrote, "And now here is my secret,
a very simple secret; it is only with the heart that one can see rightly;
what is essential is invisible to the eye." And, in the Bible, Moses told
the Isrealites that God sent them into the wilderness to "learn what
is in your heart." What is wonderful and exciting about writing is that
something invisible to the eye can express itself. What you did not know
you knew comes out as the words spill across the page. It is a cleansing
and a self-enriching experience. No one else can do it for you. You are
unique. Love yourself; love your uniqueness; and get to know the real
'you' as the words flow.

While many striving authors attempt to tap into something called
'creativity,' searching for some *force* (reminiscent of *Star Wars*) to
spur them on to success, spilling out unique verbage and insight, I
am inclined to believe they would do well to step back and read the

classics. Begin at the beginning: the *Bible*. According to this great book, God created man in His own image. Think about that. What is it about humanity that separates man from other animals? What is it about each individual that makes him or her unique? Sometimes it takes a confrontation with death or squalor, war or disease, for a person to appreciate and recognize (re-know) the essence, the spirit, the soul within. The body decays; the soul persists. Read William James' work for his study of human nature and the varieties of religious experience. Once it has perceived 'the truth,' the mind reverts to discourse and the written word.

In the 2004 Mythic Journeys Conference in Atlanta honoring Joseph Campbell, both Robert Bly and Michael Meade made impassioned pleas for participants to honor Campbell not just by reading his works, but by "doing as he did – tell stories!" And it is true; the only way to give birth to a truth or vision is to take it inside yourself, make it your own, and then give it back to the world, refreshed by its incubation in your soul. This is where myths are born … but more about myths later.

Let us approach this topic from another vantage point. It was interesting for me to find, while doing research on another project, many of the world's scientists and mathematicians were also astrologers. Astrology has been used by many to explain man's place in the universe, in the scheme of things (should there exist an underlying 'scheme'). I found an old book in my father's library called *A Manual of Cheirosophy*. It was written in 1885. In the preface, the author, E. D. Heron-Allen, states, "[M]y aim in writing this *Manual of Cheirosophy* having been simply to place before the world a concise and clearly comprehensible epitome of the principia of a science which opens a page of the great book of nature to the student who will diligently read it … and which endows all men who will study it with the foresight

which, under the name of intuitive faculty, is the cherished possession of so few, enunciating and solving the great problem of 'Know Thyself.'" Cheirosophy, I found out, is a means by which the past, the present, and the future can be read "in the formation of the hand." But, evidently, it is more than mere palmistry. The point here, however, is that every successive generation has sought a way to fathom the mysteries of the universe outside of 'pure' science. Einstein himself pointed out the "most beautiful experience we can have is the mysterious. It is," he said, "the fundamental emotion which stands at the cradle of true art and true science." And, he admonishes, "[w]hoever does not know it and can no longer wonder, no longer marvel, is as good as dead, and his eyes are dimmed." Marvel, wonder, delight, these are the words shared by the great men of science as well as historians and artists in man's eternal quest for the meaning of the mysteries, of life.

> *Until we accept the fact that life itself is founded in mystery, we*
> *shall learn nothing.*
>
> Henry Miller

Spiritualists believe we only use a fraction of what our minds are capable of. They believe people create veils (the etymology of reveal being 'remove the veil') which prevent them from seeing clearly. It is necessary for us all to recognize the veils' existence and to consciously attempt to remove them, to take away the rules and regulations that blur our vision of truths and allow our inner voice, our creative muse to speak.

> *What shall be my attitude toward other life? It can only be a piece*
> *with my attitude toward my own life. If I am a thinking being, I*
> *must regard other life than my own with equal reverence for I shall*
> *know that it longs for fullness and development as deeply as I do*
> *myself.*

*Man can no longer live for himself alone. We must realize that
all life is valuable and that we are united to all life. From this
knowledge comes our spiritual relationship with the universe.*

<div align="right">Albert Schweitzer</div>

To begin your journey of realization and writing, consider keeping a diary. "A diarist is a writer who watches himself watching himself." (Edward Robb Ellis) Write about what you can see and what you cannot 'see.' Have you ever experienced the 'crucible effect'? Crises are change-points. Crises show us who we really are. Divorce, bereavement, disease, war, persecution, loss of a job, all force us to realize what is vital in life and what is peripheral. Anger is toxic. Unexpressed, it will erode your inner peace. The pages of a diary provide a safe place to explore anxious or painful feelings. Utilize your diary to empty out the pockets of your life.

*We are here to abet Creation and to witness it, to notice each thing
so that each thing gets noticed. Together we notice not only each
mountain shadow and each stone on the beach but we notice each
other's beautiful faces and complex natures so that Creation need
not play to an empty house.*

<div align="right">Author Annie Dillard in a statement
on 'The Meaning of Life' for *Life Magazine*</div>

A little history: diarists were prolific in the nineteenth century. A diary was the equivalent of a Confessional. Also in the 19th century, correspondence letters were most revealing. Letters were written on a daily basis, sometimes just to ask if an individual could visit a neighbor at a certain hour (preferably in the daylight hours according to the rules of proper etiquette). There were no telephones and it would be most improper to just show up at the doorstep. Then there were newspapers to consider as a kind of memoir. Meetings of neighbors and meals served

at receptions in private homes were just as important as world events in the nineteenth and early twentieth century. News and correspondence took time in those days. It was, for example, five weeks before the British heard that their troops had successfully burned the nation's Capital and the President's Mansion (as the White House was called before it was rebuilt and painted after the fire). The year was 1814. So while the news was delivered and being digested by the British, the Americans had already commenced reconstruction. The facts were correct, but the emotions reined and the plan was ultimately defeated. Washington remained the Capital of the new nation.

Not content with facts, authors do not simply find out the when and where, but they evaluate what they find. And since each one of us is different, our perspective is different. The writer of memoirs writes what he or she felt when the event happened. These feelings often paint a more powerful picture of the occurrence than mere facts.

For wonderful examples of diary or memoir writing, I recommend Persig's, *Zen and the Art of Motorcycle Maintenance* and Frank McCourt's poignant *Angela's Ashes* (winner of the Pulitzer Prize).

Today, we still have a need to write, but writing has become quickly written, abbreviated e-mails, short status posts on social media – some with a 140 character limit – and a lot is lost in the translation. As Anthony Pitch, historian and author of several books on the British burning of Washington (which we described in part above) said, today's private thoughts are written on "paper purchased at Staples around the corner from Starbucks." Nevertheless, the need to write survives. It is part of human nature.

John Livingston Lowes (1867–1945) author of *The Road to Zanadu*, said he wrote the book because it "simply came" as "the imaginative

energy itself" surprised and forced him to write. This wonderful book tells the story of the genesis of *The Rime of the Ancient Mariner* and *Kubla Khan*. Published in 1927, the book literally dazzled the public. Beyond being simply a stale, scholarly guide to the two Coleridge poems ("two of the greatest poems of our language," according to the *Yale Review*), it was "a landmark and a guide post in literary scholarship" (*The Saturday Review of Literature*) and "a biggish, jolly book, whose effortless ease conceals the years of toil that went to its making, and pleasant reading from end to end." (John Bakeless, author and editor) In a period of American history when Germany was the center of intellectual endeavor and culture, it was exciting to have an American inspired to write such a tome. But for the author, it was "an adventure like a passage, through the mazes of a labyrinth, to come out at last upon a wide and open sky." Professor Lowes said *The Road to Zanadu* was but a symbol of something intangible. It was research into the energy of the imagination itself. "We sometimes forget creative energy creates," he warns us. Take a word. Mix it with thought. Out of the mix comes something new and unique. "The ways of creation are wrapped in mystery; we may only marvel and bow the head."

Your assignment: slow down, take time out. Express your words without a 140 character limit. Do not just 'hear', listen; do not just 'see', look.

4

Back to Words

[T]he artist, like the God of creation, remains within or behind or beyond or above his handiwork, invisible, refined out of existence, indifferent… .

James Joyce

*W*ords come to us from many places and they come with a history, with a story. Their story can come from their etymology, but it can also come from their actual use at a given place in a given time by a given person. Some words come alone but most come in company with other words. As to the latter, I cannot stress enough the importance of grammar. English does not, like so many other languages, add endings to words to explain a word's use in the sentence. Rather, its position within the sentence dictates the word's significance. It is essential to know syntax, that is, the arrangement of words in a sentence, but writing has become quickly written, abbreviated e-mails, short status posts on social media – some with a 140 character limit – and a lot is lost in the translation and to recognize the proper positioning of words (with the appropriate punctuation). Having a strong command of syntax will allow you to reproduce the same in your own writing. A delightful example of misplaced positioning is the following:

> Mrs. Smith was awarded a bronze plaque as Jefferson County Mother of the Year for having borne ten children by Judge Jones in ceremonies at the community center yesterday.

Another one:

> Mouth to mouth artificial respiration can be used on anyone
> who has swallowed something that will block his breathing,
> especially a small child.

If you would like some homework, try punctuating the following
paragraph:

> At the banquet will be many members of Congress eating
> roast beef and members of the press as well. The waiters will
> serve the courses of soup fish salad meat and vegetables and
> dessert with three wines. For dessert women tend to prefer
> sherbet men pie and ice cream. Mind your manners and try
> not to eat too much. Please try not to drop your spoon or roll
> in your soup. Stay awake during the after-dinner speech and if
> you must yawn do so quietly.

We have had many laughs over that one!

When used effectively, grammar can contribute not only to
the atmosphere and mood of a literary work but to its power and
significance as well.

In class, we spoke of words coming to us from many places. The
United States is a melting pot and all the more rich because of it. New
words are introduced each year as people from all over the world come
to live in America and share their heritage. New dictionaries are being
published constantly to keep up with the growth of the American
English language. Today American English has become the second
largest language in the world and the secondary language of most of the
world's population. For writers, this language with its annual growth
in vocabulary provides a rich reservoir of words and with each new

word comes a taste of history and tradition from other cultures as well as added nuance. Typically, people from the same cultural background will use words or expressions taken from their native language and incorporate those into their English sentences. If used consistently, some of those words will catch on to the general population. For example, we have words like "chic" and "faux pas" from the French; "prima donna," and "cappuccino" from the Italians; "Kindergarten," "frankfurter" and "strudel" from the Germans; and "klutz," "chutzpah," and "schlep" from Yiddish speaking immigrants. In the case of 'kindergarten', it was Anna Held who came from Germany and introduced the concept of teaching younger children to the United States. (More about Anna Held in my book *'La Jolla, A Celebration of Its Past.'*)

The structure of the language that is habitually spoken strongly influences the manner in which a person understands the environment in which he or she lives. Consider some languages in which there are no adjectives or the languages in which there are no verbs. Certainly people speaking those languages have a different view of the universe. If the process of thought and content is contingent upon language, then just consider how amazing it is that we, on this small planet with the many varieties of linguistic patterns, can even begin to understand one another. Even within the United States, the language structure changes among ethnic groups and from one geographic area to another.

Common idiomatic usage is defined as slang. Someone has called slang 'a kind of linguistic exuberance.' Related to standard vocabulary, slang could be equated to dancing as it relates to music. Chesterton is quoted as saying, "All slang is metaphor, and all metaphor is poetry." (from *Words on Words, A Dictionary for Writers and Others Who Care About Words,* John B. Bremner)

Think of all the synonyms there are today for the word 'relax': ease

up, mellow out, chill, take it easy, be cool, kick back. Since relaxation is supposed to be the first step toward wisdom, intuition, and creativity, I cannot help but wonder what saying 'chill' would do toward helping a person prepare for "higher thoughts." But the real problem with slang is its short life. For the writer to emphasize a particular time/place/person/culture, slang can be useful. However, unless you wish to "date" your story, slang can make an otherwise ageless story seem dated. For example, describing a character as "cool" may seem appropriate now, but someone reading the story ten years from now will know that the story was written in 2015. Similarly, reading a book where a character or place is described as "groovy" or "out of sight" will make the reader feel that the piece was written in the 1960s.

I cannot emphasize too much the significance of the word both as a symbol and an image. This symbol or image is representative of itself and more than itself. How is this achieved? What is the desired result? Why? Before we progress to the creative aspect of words, we need to lay a good, solid foundation. Just as a building does not begin with a roof, a story does not begin without structure and background.

The background begins with the history of words, their derivation, their origin. This is their etymology and our depth and understanding of words is enhanced by their etymology. As we stated before, the English language has a rich heritage: Latin, Greek, Scandinavian, Old French, German, and more. Knowing the etymology of a word is like giving it a halo. The light (or aura) from the halo takes in the enclosure or surroundings of the word. I am attempting to portray, figuratively, the word's connotation. Unlike its connotation, a word's denotation is its definition and is finite in this instance. Definitions set limits (although there can be a process of developing definitions, of creating and molding definitions). The connotation of a word, on the other hand, implicitly means so much more than the explicit meaning. Connotation has no boundaries.

Let me give an example. The word is 'ecstasy'. In the popular sense or slang, ecstasy can mean an overwhelming feeling of joy or something akin to fanaticism or hysteria/hysterical and in street talk, even the name of an illicit designer drug. From an etymological standpoint, it comes from the distant past. In Latin, the *'ex'* means 'from' and the *'stasis'* means 'place'. Further back, it comes from the Greek, *'ekstasis'* meaning being put out of its place, distraction, trance, where the *'ek'/'ex'* means 'out', and *'histanai'* means to place or to cause to stand. According to Rollo May (*The Courage to Create*), "Ecstasy is the accurate term for the intensity of consciousness that occurs in the creative act." He calls it "suprarational" (as opposed to irrational) since it brings together the intellect, determination, and the emotions. 'Ecstasy' is the formal word, he tells us, for the "union of form and passion with order and vitality."

Nietzsche uses the word in the sense of 'out of place' when he says, "In the midst of all this life, joy, and sorrow, tragedy sits in noble ecstasy, listening to a sad distant song which tells of the mothers of being whose names are Wish, Will, and Woe." (*Birth of Tragedy*)

These are examples of the connotation of a word which takes it beyond its etymological definition. The word finds meanings which differ widely depending upon its environment (time, place, or person).

Let's step back a minute. We want you to be excited about writing, but we recognize that it takes courage to change your ways and your opinions, to leap into something that has no rules, that is spontaneous. Look at the word we just used: courage. What is its story, its etymology? Courage comes from the French word 'coeur'. Translation? Heart. Courage comes from the heart.

Courage
is not the towering oak
that sees storms come and go;
it is the fragile blossom
that opens in the snow.

Alice Mackenzie Swain

So take courage. Explore, experiment, expand. Are you excited yet? Words carry so much charisma within their very core. Consider the etymology of another word; reveal. Reveal comes from the Latin *re* (un) plus *velare*, 'to cover', also from *velum* (veil) and thus, translates to; 'remove the veils.'

The hero journey is inside of you; tear off the veils and open to the mystery of your SELF.

Joseph Campbell

Richard Strauss wrote an opera called *Dei Frau ohne Schatten* (The Woman Without a Shadow). I saw it performed in San Francisco in the late seventies. The stage was literally veiled from the audience, but as the opera progressed, one veil at a time was lifted. The audience became overtly aware of and involved in the drama being depicted on the stage. In the end, the audience was almost part of the presentation as there was no longer any veil to shield us from the performers.

One of my favorite words to research was 'text'. It comes from the Latin verb 'texere' meaning to weave. Think of writing as sewing a quilt. All the pieces with their various colors and textures are being woven together to form a beautiful spread, a fabric of words. In 1870, a prairie woman wrote: "I make them warm to keep my family from freezing. I make them beautiful to keep my heart from breaking." A poignant and powerful image. So now go weave your words.

Remember e e cummings' poem:

> *anyone lived in a pretty how town*
> *(up so floating many bells down)*
> *spring summer autumn winter*
> *he sang his didn't he danced his did.*

Or:

> *in time of daffodils (who know*
> *the goal of living is to grow)*
> *forgetting why, remember how*
> *in time of lilacs who proclaim*
> *the aim of waking is to dream*
> *remember so (forgetting seem) ….*

As a poet, e e cummings was experimental, expressing himself as an idiosyncratic individualist. Ezra Pound placed cummings' book of poetry ahead of James Joyce's *Ulysses*. cummings was also a painter and even wrote thousands of pages concerning his own aesthetics of painting. (The non-capitalization of his name came following his internment in WWI. It was his way of visually showing his desire to be less about self and more about others.)

James Joyce was also known for his "stylistic pastiches." In the period between the wars in Paris, Eugène Jolas and his wife were publishing a journal named *transition* because they liked to "daydream about new forms in art and language." And that perfectly described what was happening to James Joyce whose writing was included in the journal.

An anecdote that epitomized James Joyce's approach to the technique of writing goes like this: Joyce, while working on *Ulysses*, met a friend, Budgen, on the street in Paris. Joyce told his friend that he had been

working all day and had produced only two sentences. "You have been seeking the right words?" Budgen asked. "No," replied Joyce, "I have the words already. What I am seeking is the perfect order of words in the sentences I have." Not everyone, of course, agrees on the artistic merit of Joyce's work (although *Ulysses* is considered by most as the finest written novel of the twentieth century). They become annoyed at the difficulty in understanding Joyce's 'vocabulary.' So, in their minds, if literature is to be a means of communication, it should be clear to the reader.

Consider the following from *Finnegan's Wake*:

> [O]r had topsawyer's rocks by the stream Ocanee exaggerated themselves to Laurens County's gorgios while they went doublin their mumper all the time.

Or from *Ulysses*:

> Coffined thoughts around me, in mummycases, embalmed in spice of words. Thoth, god of libraries, a birdgod, moonycrowned.…

It takes many rereads, but I believe it warrants the time. Joyce will come through and start speaking to you. Of course, his references and cross-references may take a lifetime to comprehend, but I also think that may have been his intention! However, for more clarification, read Joyce's *A Portrait of An Artist as a Young Man*. In this work, Joyce clearly and lucidly writes about the "phrases of artistic apprehension" corresponding to unity (*integritas*) and harmony (*consonatia*). "You apprehend it as complex, multiple, divisible, separable, made up of its parts, the result of its parts and their sum, harmonious. That is *consonantia*." There is a third level or term he uses: *claritas*. "This supreme quality is felt by the artist when the esthetic image is first conceived in his imagination." The image, he says, is luminous in the mind's eye "arrested by its wholeness and fascinated by its harmony." He

compares *claritas* to a spiritual state taking the subject of aesthetics to its highest level. This is the thesis of *Portrait of the Artist as a Young Man.*

Joyce and contemporary and fellow Parisian transplant Gertrude Stein were not writing books for a story line. They wrote so we, the readers. might have an experience. It is an adventure with words. Miss Stein's writing consists of structurally spontaneous (oxymoron?) compositions with words coming across like music with harmony and rhythm. "I like the feeling of words doing what they want to do," she said, "and as they have to do when they live where they have to live. It is thought thinking itself." Miss Stein, reacting to the way the Cubists in Paris were painting in the twenties, took her writing, like their canvasses, and moved beyond the limitations imposed by three-dimensional perspective. At this time, her writing was like a verbal still life but a still life in the Cubists' way of thinking or seeing. She attempted to capture the thought or the image at different angles simultaneously. The following is an example of Stein's explanation of her "experiment with language" and her way of explaining the skill and process of writing and maybe a little of that which only time and maturity can teach:

> A sentence is inside itself by its internal balancing, think how a sentence is made by its parts of speech and you will see that it is not dependent upon a beginning a middle and an ending but by each part needing its own place to make its own balancing, and because of this in a sentence there is no emotion, a sentence does not give off emotion. But one sentence coming after another sentence makes a succession and the succession if it has a beginning, a middle and an ending as a paragraph has does form create and limit an emotion....

> When I first began writing really just began writing, I was tremendously impressed by anything by everything having a beginning a middle and an ending. I think one naturally is

impressed by anything having a beginning a middle and an ending
when one is beginning writing and that is a natural thing because
when one is emerging from adolescence, which is really when one
first begins writing one feels that one would not have been one
emerging from adolescence if there had not been a beginning and
a middle and an ending to anything. So paragraphing is a thing
then anyone is enjoying and sentences are less fascinating, but then
gradually well if you are an American gradually you find that really
it is not necessary not really necessary that anything that everything
has a beginning and a middle and an ending and so you struggling
with anything as anything has begun and begun and began does
not really mean that thing does not really mean beginning or begun.

William Carlos Williams, a poet whose writing was also inspired by the so-called *avant garde* paintings that were beginning to become popular in the twentieth century during the teens and on through the twenties and thirties, attempted to do what he saw the artists doing. He took inanimate objects and using language, gave them life. An example of this can be seen/read in one of his early poems, 'Winter Quiet':

> *tense with suppressed excitement*
> *the fences watch where the ground*
> *has humped an aching shoulder for*
> *the ecstasy.*

When writing a story, think about a new way to look at the configuration of phrases. Reread the philosophy presented by Gertrude Stein or consider the writing philosophy of Aristotle presented in his tome, *Poetics*. Plot, according to Aristotle, "has a beginning, a middle, and an end; the roots of the middle are in the beginning; the roots of the end are in the middle, the end must complete what is begun in the beginning."

Question, always question. Compare Gertrude Stein and Aristotle's advice. Are they really so different? Do you believe life provides endings to situations? Do events simply blend one into the other? What about surrendipity?

We are constantly changing and growing, maturing and evolving throughout our lives. Our job as we grow is to integrate all these parts, all these influences on our lives. Remember, the full potential of the acorn is to be a mighty oak.

Below is a note Patty Daly sent to me. It summerizes so closely what this book is all about. We share the same name, although we are not related. Yet we definitely are kindred spirits as you shall see when you read the following:

> *I have always been an observer of my environment and life. As a child, drawing provided my understanding of both. Later, I also found a friend in writing. Drawing and painting was my peace-ground and writing became my therapy. It was not necessarily about the content, it was about the process of non-thinking, giving clarity in my own world. I realized blank creativity was how I communicated with my inner self. An infinite epiphany!*
>
> *After a corporate career, I returned to school for Interior Design. I wanted to share my talents in a more creative professional manner. This fueled my spirit and I found myself releasing in many expressional forms of art and poetry. My inspiration comes mostly from nature's well. While my poetry and musings are usually spawned from the artistic perception. I feel it is humankind's responsibility to learn from the past, to grow and protect all and pass on our wisdom to future generations, as the stewards of this earth.*

*Life and earth are our spirit tools to make all of us glow. Art is
the untapped form. And writing is best said by Ralph Waldo
Emerson: "language is fossil poetry." I wish to imbue ma* with
the hope to enhance all that glows and grows from within. We all
should participate in sharing ourselves and learning from everyone
else. It all comes down to the joie de vivre.*

[**ma* refers to the nothingness we defer to in the mind. It
is a spatial concept, the space before perception. It is the
clarity, epiphany and unknowable knowledge we are unaware
of using. It is in that place where we find answers through
perception, a natural fluid flowing in time without time
calculated.]

John Gardner described the root of creativity as a mystery. "In some
apparently inexplicable way the mind opens up; one steps out of the
world." This sense of the inexplicable led him to say: "All writing requires
at least some measure of trancelike state." Ultimately, "the imaginary
becomes the real."

Here is how I believe, you, the writer, can transpose the imaginary
into words and to transpose is like magic. It cannot be taught. The
creativity, the imaginary comes from inside your mind. But we hope,
in this book, to inspire you to listen and heed your unconscious mind,
home to your creative muse. Your muse is shy and elusive. But your
conscious mind can tap in and train your unconscious to express itself,
thus releasing the words. Then harness those words and allow them to
gallop into writing. But we are getting ahead of ourselves. Plus my horses
probably would not like the analogy.

Inspiration can come from more than what we might loosely define as
'beauty'. John Constable, the great landscape artist, wrote that "[t]he sound

of water escaping from mill-dams ... willows, old rotten plants, slimy posts, and brickwork, I love such things These scenes made me a painter, and I am grateful." (from *On the Laws of the Poetic Art,* Anthony Hecht)

Now find and harness your source of inspiration. (My horses won't mind!)

Umbrella teddy bear muddy sneakers picket fence

5

Music

Some words are made up for the rhythm, the music, the sound. 'Primitive' (in quotes because our meaning here is rudimentary as opposed to intellectually inferior) cultures tend to be more in touch with the physical, the kinesthetic aspect of words. In Sanskrit, for instance, things are sounds. In our language, consider onomatopoeia. (Greek, *onoma, onomatos,* a name, and *poiein,* to make; hence, to make a name) Some examples: tinkle, buzz, chickadee, hush and meow. Alexander Pope (*Essay on Criticism*) stated, "The sound must seem an echo to the sense." My advice is to use this device sparingly.

"Music makes you feel hungry for more of it," said Toni Morrison in an interview. "Literature should do the same thing." Of all the contemporary writers, her work is on the top of my list for verbal musicality. Morrison not only recites the words of her black African heritage but she writes in a metered frame, song-like when read aloud.

She chooses simple vocabulary and chops her phrases to flow easily, chant-like at times, reminiscent of black preachers.

> *Here ... in this place, we flesh! flesh that weeps, laughs; flesh that dances on bare feet in the grass. Love it. Love it hard. Yonder they do not love your flesh. They despise it. They don't love your eyes; they'd as soon pick them out.... And o my people, they do not love your hands. Those they only use, tie, bind, chop off and leave empty. Love your hands...! You got to love it, you...! More than eyes or feet. More than lungs that have yet to draw free air. More than your life-holding womb and your life-giving private parts, hear me now, love your heart. For this is the prize.*
>
> (*Beloved*)

There is a certain affinity between musical rhythm and literary rhythm. Repetition of words and the recurrence of phrases make for rhythm. Even the placement of long and short syllables can produce cadence. For example, in Longfellow's *Evangeline*, "THIS is the FORest priMEval. The MURmuring PINES and the HEMlocks...." The sounds in literature and poetry emulate nature. They can also resound with meaning. Rhythm is an instrument of art.

> *The creative act is not hanging on, but yielding to a new creative movement.*
>
> Joseph Campbell

William Faulkner said, "Life is motion.... The aim of every artist is to arrest motion, which is life, by artificial means and hold it fixed so that a hundred years later, when a stranger looks at it, it moves again since it is life."

Words in themselves arrest motion. We, the writers, have taken the time to stop, observe with all our senses the life around and within ourselves. We grab our observations and, to the best of our ability, convert

them into words. We attempt to recreate life and so we try to make our words appear to move as lives and nature move. Consider this wonderful sermon from *The Sound and the Fury* (be sure to read this out loud):

> *He was like a small rock whelmed by the successive waves of his voice. With his body he seemed to feed the voice that, succubus like, had fleshed its teeth in him. And the congregation seemed to watch with its own eyes while the voice consumed him, until he was nothing and they were nothing and there was not even a voice but instead their hearts were speaking to one another in chanting measures beyond the need for words, so that when he came to rest against the reading desk, his monkey face lifted and his whole attitude that of a serene, tortured crucifix that transcended its shabbiness and insignificance and made of it of no moment, a long moaning explosion of breath rose from them, and a woman's single soprano, 'Yes, Jesus!'*

Read the poetic rhythms, the imagery, the emotional intensity (sorrow, despair, rejoicing) in this passage. This sermon was given on Easter in the novel. It represents not the Passion story, however, but the emotional climate of the Passion story: life, death, and the resurrection of Christ. Well written, words can do so much more than tell a tale!

"To seek, beneath the universal strife, the hidden harmony of things." (Will Durant) This applies to readers and writers alike. Life is rhythm, movement, harmony as well as chaos. Our words should reflect all of these. Rhythm does nothing more nor less than enhance syntax. One of the most powerful mimes of life is sound.

"Music has charms to sooth the savage beast. Music has the power to enchant even the roughest of people." This proverb comes from the play *The Mourning Bride*, by William Congreve, an English author of the late

seventeenth and early eighteenth centuries. To enchant with the hidden harmony, that is also a writer's task.

Many of the Baroque composers had a sacred belief in precise geometry within all matter. Their music was a reproduction of this. Baroque music moves the listener toward harmony, order, and inspiration. Listening to classical music also facilitates the thinking process. Don Campbell, author of *The Mozart Effect*, writes about his research on the effect that classical music has on the brain. Music somehow reaches our brain's intuitive area. It touches a part of the brain which causes our nervous system to automatically respond and react. A child with Williams Syndrome (where children have remarkably fluent language skills but have great difficulty with spatial tasks; have striking ability in recognizing faces but difficulty with problem solving; and have an average IQ of about 50) once said, "Music is my favorite way of thinking."

In 1993, physicist Dr. Gordon Shaw reported that college students who listened to Mozart's *Sonata for two pianos in D major* (K. 448) saw their IQs increase substantially on tests of spatial-temporal reasoning – a skill related to math. However, the increase was only temporary. "It is not that the Mozart effect will make you permanently smarter," he reported to the Los Angeles Times in 1993. Hearing this music, he speculated, might provide "a warm-up exercise" for parts of the brain that perform high levels of abstract thinking. It was back in 1973 a paper was written on brain theory that caught the attention of Gordon Shaw. Dr. Shaw had studied with Nobel Laureate Hans Bethe and was an expert on particle physics. With the assistance of graduate student Xiadan Leng, Dr. Shaw devised a computer model to match musical notes to brain patterns and the result, although not Mozart, did match something resembling Western classical music. In another test, Dr. Shaw divided students into three groups. Using three environments, one exposed to relaxation

tapes, one to Mozart and one to silence, the Mozart listeners saw their IQ levels rise as much as nine points. However, the increase began to dissipate after ten minutes. In 1998, Dr. Shaw co-founded the non-profit Music Intelligence Neural Development Institute where a curriculum was developed using a computer program and piano keyboard training to improve math learning. It is now offered in sixty-seven elementary schools. Dr. Shaw also published the book, *Keeping Mozart in Mind*. He died in 2005, but his work continues.

Mozart appears to strengthen the neural connections that underlie mathematical thought. Other researchers have used the two piano sonata to improve the spacio-temporal reasoning of an Alzheimer's patient and to reduce the number of seizures in epileptics.

A final example of how creativity (music in this case) connects the mind and body is as follows: Bach and Mozart, not wanting their students' creativity to be devastated by repetitive études, created their own piano lessons. Bach wrote the *Inventiones & Sinfonias* and the *Well-Tempered Clavier* as enjoyable keyboard compositions for the student. Mozart wrote *Sonate Facile* for teaching purposes. To concentrate on the technical for its own sake will never produce a creative new work. The same analogy applies to writing and any of the other creative arts.

The Hungarian, Zoltan Kodaly (1882–1967), was another of many pioneers in musical education who observed the beneficial consequences when music was added to the educational experience of children. The music stimulated the intuitive side of the brain and the learning process accelerated.

Dr. Giorgio Lozanov, once the only psychotherapist in Bulgaria, moved to Austria to head an institute that continues his research in the scientific inquiry into the relationship between certain music and the learning process. Music acts, he writes, as a kind of transmitter. "As the

phrases (in this case, phrases used in the study of a foreign language) were spoken in exact accordance with the tempo of the music, the music in a way transported the text into the subconscious mind of the listeners."

From birth, we have patterns in our brains. We recognize sounds and since every language has a pattern or rhythm, the brain picks up on this. That is why, the younger the child, the easier it is to learn a language. No questions asked. Simply learned from absorption. My mother spoke four languages and her uncle spoke five, all learned as children. If we could have our children exposed to the study of languages in their earliest school years, we might instill a better understanding as they become adults of other cultures and traditions. For so much of a country and culture's history is transcribed into their language.

In an article called 'Incentive to Inspire,' Raymond Greiner points out one of the issues in today's society.

> *If we individually aspire to embrace compassion and tolerance global social design may redirect toward an improved world. At this point it may seem impossible but hope remains. Ongoing hate, evil and dysfunction will continue if we allow it. We must become inspired to follow an improved pathway seeking peaceful solutions, placing values directed toward higher purpose.*

> *The voice of destiny sings in varied rhythmic tones, often off key and out of tempo, like a catbird singing in a thorn bush. Then the sky opens and darkness becomes light as clouds of doubt vanish.*

So take the "voice of destiny" and consider its tone, even off key, as music. For music has power, the power to revive myth. In music, there are no appearances. Music represents a plane of consciousness beyond form. It is the "metaphysical of everything physical in the world." (Nietzsche) Can you imagine life without music?

Music

Music is your own experience, your thoughts, your wisdom. If you don't live it, it won't come out your horn.

Charlie Parker

Silence somehow suffocates. Music triggers emotional response, joy and sadness, serenity and chills. Take the 'motion' out of 'emotion'.

Dickinson has a halt meter, like a hobbled horse or a Chinese woman who has bound her own feet!

Professor Camille Anna Paglia

Feel the movement as Faulkner describes a wave in the Yazoo River. "It reared, stooping; the crest of it swirled like the mane of a galloping horse and phosphorescent too, fretted and flickered like fire." Faulkner says that you, the writer, don't write to show your versatility. You write because you are human and it is inherent in your very being to render "the ageless, eternal struggles which we inherit and we go through as though they'd never happened before, shown for a moment in a dramatic instant of the furious motion of being alive; that's," he said, "all any story is." The emotion you feel is stopped artificially and emphasized by means of your pen or your keyboard so that the readers will see it as motion and feel in themselves the force and tension, the sweat and the agony, in short, the exaltation of living. That is the motion of life caught by the writer.

Robert Frost observed, "No tears in the writer, no tears in the reader. No surprise for the writer; no surprise for the reader." (*The Figure a Poem Makes*) Live life to the fullest. Open your eyes and see the wonder, the excitement, the clashes and clammers, the cataclysms, the movement of what we call LIFE. Let the music of life fill your heart and translate it with writing filled with tempo and beat.

It begins in delight, it inclines to the impulse, it assumes direction with the first line laid down, it runs a course of lucky events, and ends in a clarification of life – not necessarily a great clarification … but a momentary stay against confusion. It has denouement. It has outcome that though unforeseen was predestined from the first image of the original mood – and indeed from the very mood. It is but a trick poem or no poem at all if the best of it was thought of first and saved for the last. It finds its own nature as it goes and discovers the best waiting for it in some final phase at once wise and sad.

<div align="right">Robert Frost</div>

Listen to Mozart or Bach. Free up the waves of images and impressions which are locked behind our daily world of practicality and grind. Relax. Try listening to the *Rondo-Allegretto grazioso* from the *Sonata in F Major* for violin and piano or one of the Brandenburg Concertae. Practice "earobics" for awhile. Do not forget to have a paper and pencil ready.

With the music in the background, the windows of your mind should be wide open. Think of the pitch as mood. Think of the rhythm as pattern. Let your imagination flow! Now go ahead and write.

6

Imagination

You can't depend on your eyes when your imagination is out of focus.

Mark Twain

Imagination is the beginning of creation. You imagine what you desire, you will what you imagine, and at last you create what you will.

George Bernard Shaw

The writer needs to liberate the imagination of the reader. The base word in 'imagination' is image. Images call forth words to express and reinforce themselves. Often the images remain incomplete and words are needed to finish the job. Abstract connections can be made; fantasies can be completed; images can be fuzzy or fleeting or just plain incomplete, but words can render them free. "Look to the image concealed within the emotion," (Carl Jung) and then transform it into art.

Let your words literally "spill out the truth." Let your eyes and your mind's eye (memories) bear witness to your reality. The painting on the cover of this book was done in just this way. At the end of day, when I was painting a landscape, I gathered the unused globs of oil paint from the palette and, with a palette knife, spread the colors across an empty canvas. A week of doing this and the second canvas was covered with all sorts of colors and shapes. I turned the canvas upside down and sideways until I glimpsed images peeking through. Carefully, I allowed

the forms to present themselves. Out came the Princess, then the unicorn, the old castle and the trees. All these were shapes and forms I had seen in Avignon at the *Palais des Papes* years before. They were there but they were not there. These images came from my memory (or imagination) and were just waiting to be expressed. "What was to go on a canvas was not a picture but an event," said our neighbor in La Jolla, Dr. Seuss.

And according to Henry David Thoreau, "This world is but a canvas to our imagination." And even further back in history, Plato compared memory to a slab of stone. Nothing is lost through a lifetime.

Words reflect our human particularity: we are social beings. Within a single word may be contained a complete concept or a notion. First the words are spoken, even if it is to ourselves, and then they are written down. Once they are written, words go public. Writing is a dialogue whether it be private internal discourse or public external with readers. However, keep in mind, words actually create an audience by being written. To the reader, the word takes on a new and different form/ image/thought/pattern. The author cannot control the imagination of the reader. The reader relies on his or her own past, his or her own memories to enhance the images and ideas provoked by the words. "Give what you have. To someone (else) it may be better than you dare to think." (Longfellow)

Sartre said in his introduction to Jean Genet's work, "The imagination represents objects to us in such a way as to incline our judgment in the direction we wish." Take the work 'represent'. Understand it as *re* (again), and *present* (as in presentation). The author cannot nor should he or she want to possess the words to which he/ she has given birth (i.e. created). Once written, see the words as a gift, offered to the reader freely and without hitches.

Write about everything. The most trivial may be the most significant. Let the words flow; invent them if need be. Take for example the following piece from James Joyce's *Ulysses*:

> (A dog walking up the beach with his owners discovers the carcass of another dog washed up by the sea at Sandymount strand). *Unheeded he kept by them as they came toward the drier sand, a rag of wolfstongue redpanting from his jaws. His speckled body ambled ahead of them and then loped off at a calf's gallop. The carcass lay on his path. He stopped, sniffed, stalked round it, brother, nosing closer, went round it, sniffing rapidly like a dog all over the dead dog's bedraggled fell. Dogskull, dogsniff, eyes on the ground, moves to one great goal. Ah, poor dogsbody. Here lies dogsbody's body.*

Do you experience the dog's movement coming up to and then walking around and around the dead body? Do you see how the syntax and the rhythm work together to imitate the dog's movement?

Early in his chosen métier as a writer, James Joyce had attempted poetry and even theatre writing. Although his success came when he switched to writing prose (in 1904, the same year that he and Nora came together as a couple and left Ireland for Paris), he never forgot what he had learned about music (from the poetry) and drama (from the theatre), two natural states of mind in his native land.

Joyce took seven years to write *Ulysses*. His next novel, *Finnegan's Wake*, took seventeen years to complete. Talk about fastidious! However, Joyce's work, in my humble opinion, epitomizes infinite patience, total commitment, and dedication. His writing represents layers upon layers of nuance, historical references and mythological allusions, metaphysics, drama, and the universality of the most trivial things. To read James

Joyce, I feel, is to experience the ultimate artistic poetic aspect of
language. Joyce focuses on the message, the content for its own sake. The
language calls attention upon itself. "When you read Joyce, what you get
is radiance. You become harmonized…. It is not teaching you a lesson;
it is feeding you. It gives you spiritual balance and spiritual harmony."
(Joseph Campbell)

Look for patterns and pauses. Consider the latter aspect of writing;
the pause. What is not said is often more important than what is said.
My late mother-in-law, Georgeanna Lipe, was a painter and what
she did is the same as what we are describing as the pause in writing.
Georgeanna studied medicine at Vanderbilt University in the thirties.
After graduation, she began her career as a medical illustrator. Years later,
after marriage and motherhood and a move to California, she decided to
paint. And she chose watercolor as her medium. This amazes me because
it is what you leave out that is just as, if not more, important than what
you put in a watercolor painting. From having to depict everything
methodically as a medical illustrator to painting with thin water soluble
colors where the paper is often shown peering through as part of the
composition is an incredible feat.

Returning to words, begin by letting the words flow. Then when
some time has elapsed (at least twenty-four hours), cut to the core. Often
insinuation, implication, inference is more effective than fact. Hemingway
apparently agonized over his 'one true sentence.' "Less is more" was his
theme. As he said, "A writer's problem does not change. It is always how
to write truly and having found out what is true to project it in such a
way that it becomes part of the experience of the person who reads it."
(Ernest Hemingway in Carlos Baker's *Hemingway, The Writer as an Artist*)
Hemingway's method was to make long lists of words, often infinitives, to
describe an experience. The lists were like verbal talismans helping him

achieve what would end up reading or sounding like a total immersion "in the sensuous experience of living." Each and every writer must find a system or style which will make the vision flesh; a style which lets each image or story be born from a single pure emotion or, as Hemingway said, an "under-code" that allows a writer to create "the real thing, the sequence of motion and fact, which makes emotion." The predominant style of Hemingway is lean, pared, economical, and succinct. In his words: "The first and most important thing of all, at least for writers today, is to strip language clean, to lay it bare down to the bone."

Faulkner, on the other hand, is flamboyant, rich, decorative, embellished, sometimes poetic, sometimes a hallucinating language full of texture and rich sensory impressions. They could not be more different; but then, are we not all, as humans, very different? The key to you as a writer is "to thy own self be true." Write the way you perceive and the way you feel.

Hemingway made some pertinent observations on esthetic principles in *Big Two-Hearted River*: "The only writing that was any good was what you made up, what you imagined…. You had to digest life and then create your own people." Writing he says, using the voice of his protagonist, Nick Adams, had to be done "from inside yourself…. He felt almost holy about it. It was deadly serious. You could do it if you would fight it out. If you lived right with your eyes." He says he knew how the painter Cézanne would do it. For example, how Cézanne would paint *Mont Sainte Victoire* over and over, creating the atmosphere he was experiencing and developing with paint and palette knife. Then, once completed, the artist was gone. But the emotion which left his palette remained on the canvas as a gift to us who love his paintings.

Art of any sort is a challenge and Hemingway respected the challenge; in his case, the challenge of being a good writer. "[B]ut isn't

writing a hard job, though?" he remarked rhetorically to Gertrude Stein. In the final analysis, Hemingway regarded writing as a *controlled personal mythology*. More on that later.

To paraphrase C. Day Lewis, do we write to be understood or do we write in order to understand? It is so often that a writer, be he or she a student or a published author, looks at the words which have spun themselves onto a page and says, "Where did that come from?" First the image, then the thought, then the word, it's magic! Remember what Hemingway said, fact plus motion equals emotion. Try Hemingway's exercise. It will help you avoid the common and annoying overload of adjectives found in much of today's 'lesser' novels and romances.

As an assignment, read a good book and understand what it was that inspired you within its pages. Then take a piece of paper and let words fall from a pen or the keyboard. Try to follow the words as you would a path in the woods. Explore with the words. Don't rationalize, forget logic. Let the words lead you to wherever they want to go.

Happy Journey!

7

The Mystery

> *But the artist appeals to that part of our being which is not dependent on wisdom; to that in us which is a gift and not an acquisition – and, therefore, more permanently enduring. He speaks to our capacity for delight and wonder, to the sense of mystery surrounding our lives; to our sense of pity, and beauty, and pain.*
>
> Joseph Conrad

*M*ystery is a truth so profound (deep and obscure, Latin, *profundus; pro*, forward, and *fundus*, bottom) that it is like a thimble tossed into Niagara Falls. And yet, we can respond to it. "Until we accept the fact that life itself is founded in mystery," wrote Henry Miller, "we shall learn nothing."

Writing is an art form which expresses this mysterious element most clearly. In this vein, Elizabeth Hardwick, critic, essayist, fiction writer, and co-founder of The New York Review of Books, wrote "I'm not sure I understand the process of writing. There is, I'm sure, something strange about imaginative concentration. The brain slowly begins to function in a different way, to make mysterious connections."

There is magic in imagination; of that, I am sure. The base of the word 'imagination' is image. But let us use our imagination and cause 'magi' to be the base. The connotation of magi is guru, priest, soothsayer. The historical roots are from the East, the priestly caste in

ancient Media and Persia who supposedly had occult powers, and in the West, the three wise men in the Bible who came bearing gifts for the infant Jesus. The latter actually came from the East which raises further the question of the significance of their 'gifts.' However, we shall pass that question here. The idea I wish to pursue is the magic in imagination.

"What we observe is not nature itself, but nature exposed to our nature of questioning," said Werner Heisenberg (1901–1976), a German theoretical physicist and one of the key pioneers of quantum mechanics and winner of the Nobel Prize in Physics. And to repeat this thought but from a different vantage point, Joseph Campbell said: "The entire heavenly realm is within us, but to find it, we have to relate to what's outside." Thus the common thread which ties all mankind together, is found not without but within. We are all tied together in what Carl Jung called the "unconscious mind of mankind" or the "noosphere" (collective human consciousness) of Teilhard de Chardin. The oldest mysteries and the latest science all suggest that our success or failure as a species is linked directly to our relationship with creation. We are part of all we can see.

"To sit on rocks; to muse o'er flood and fell;
To slowly trace the forest's shady scene,
Where things that own not man's dominion dwell,
And mortal foot hath ne'er or rarely been!
To climb the trackless mountain all unseen,
With the wild flock, that never need a fold,
Alone o'er steeps and foaming falls to lean,
This is not solitude: 'tis but to hold
Converse with Nature's charms,
and view her stories unrolled."

Lord Byron

We must learn to be receptive to the intelligence of the universe whatever form it may take. Reception comes when we learn to listen. That is the real meaning behind the pause in the written word we referred to in the last chapter. The readers need to pause and let our words speak to them on a personal level. We writers need to allow that pause to happen by not overwriting. With writing, just as in painting, it is just as much what you do NOT write as what you do. Art demands we let go. The irony is that we always make demands and want more and our mind races ahead. We are so speeded up, we tend to ignore what is here and now and close to us (emotionally and physically). Try to be present to where you are and to what you are doing.

They say our bodies contain all the information of the universe recorded holographically. Did you know that if you break a hologram, every part, each piece contains the whole? But way before the hologram, Buddhists wrote of the Indra's Net. What is the Indra's Net? Read the Avatamasaka Sutra (Francis H. Cook: Hua-Yen Buddhism The Jewel Net of Indra, 1977), the Buddhist analogy or representation of the concept of interdependent causation.

> *Far away in the heavenly abode of the great god Indra, there is a wonderful net which has been hung by some cunning artificer in such a manner that it stretches out indefinitely in all directions. In accordance with the extravagant tastes of deities, the artificer has hung a single glittering jewel at the net's every node, and since the net itself is infinite in dimension, the jewels are infinite in number. There hang the jewels, glittering like stars of the first magnitude, a wonderful sight to behold. If we now arbitrarily select one of these jewels for inspection and look closely at it, we will discover that in its polished surface there are reflected all the other jewels in the net, infinite in number. Not only that, but each of the jewels reflected*

in this one jewel is also reflecting all the other jewels, so that the process of reflection is infinite.

The capacity of one jewel to reflect the light of another jewel from the other edge of infinity is something difficult for our Western, linear, rational minds to comprehend. Where would be the source of origin if all nodes are simply reflections? It is here the creative side of the mind kicks in.

Then, using the creative mind, one could say that, in a sense, our bodies are holograms of the universe. In 1923, Rudolf Steiner wrote:

If we try either through sculpture, painting, or drama – indeed, through any art – to portray a human being, we endeavor to create a figure that is sufficient and complete in itself – one that contains a whole world, just as man contains the whole universe within himself in his etheric body. For he draws together the etheric forces from the whole universe to mould his etheric body within earthly existence.

The meaning of life is inside of each one of us. The etymology of the word 'recognize' is to re-know. It is already there, but often our hasty lifestyle keeps it hidden.

Combine the two base words found in the multi-syllabic word, 'imagination': 'image' and 'magi'. This is the combination which you carry inside yourself; this is the mystery. As Joseph Campbell wrote, "The entire heavenly realm is within us, but to find it, we have to relate to what's outside." See the images. Express the magic. The German lyric poet Rainer Maria Rilke (1875–1936) who created what he called the "object poem" (an attempt to describe with utmost clarity physical objects, the "silence of their concentrated reality") pointed out: "the world is large, but in us it is as deep as the sea."

On the other hand, the more cognitive we get, the more removed we may become from the instinctive experience. Observe children. Remember when you were a child. So full of curiosity and awe. For the child, anything is possible. Universal truths speak to the child within. (Since the truth is very simple; otherwise, it would not be the truth!) Here is one of my poems relating to the child within:

A Poetic Meditation

On this earth, there is oneness.
A rhythmic flow, a great symphony that is life.
Trees with roots, stems and leaves
Shells, fins, furs and wings, all living things.
Each has a purpose and to each, an end
And then … a new beginning.

Let us recapture the imagination of a child
See once more the mystery, beauty and joy of God
Playing within and behind, beyond and above.
Unite with the intimacy of commitment.
Trust takes time
But the gift is there … waiting.

In schools today, students are taught with numbers and words. The arts are progressively being pushed aside. They are considered less or not significant. "Rarer still is the institution at which a concern with the arts is consciously justified by the realization that they contribute indispensably to the development of a reasoning and imaginative human being." (Rudolf Arnheim, *Visual Thinking*) Imagination requires that we 'let loose.' Allow the creative urge to express itself. "A little boy wanted to fly, so his teacher taught him to read." (Sam Cornish, poet) Education is not something the teacher explains. Learning is a natural process

that develops spontaneously in the human being. The teacher can only encourage and provide the environment for this to happen.

> *True education makes for inequality; the inequality of*
> *individuality, the individuality of success, the glorious inequality*
> *of talent, of genius; for inequality, not mediocrity, individual*
> *superiority, not standardization, is the measure of the progress of*
> *the world.*

<div align="right">Felix E. Schelling (1858–1945)</div>

A graduate of the Rudolf Steiner College wrote of his training in Waldorf education: "Rudolf Steiner College gave me the greatest gift of all…. That gift is the precious lesson of learning to see with the spirit what the eye cannot behold." Rudolf Steiner, a somewhat controversial Austrian-born philosopher opened a school in 1919 that defied the conventions of the day. The school and the method were named (ironically) after the Waldorf-Astoria cigarette factory in Stuttgart, Germany, where this first school was opened ostensibly for the employees' children. Today there are at least four hundred Waldorf schools in twenty-seven countries.

Steiner believed education should focus on academic and artistic yet practical training. "Our highest endeavor must be to develop free human beings who are able of themselves to impart purpose and direction to their lives." (Rudolf Steiner) One of the key factors in the Waldorf approach to education is an appeal, especially during the early years before second grade, to imagination, touch, movement, and feeling. In fact, reading is not introduced until the end of first grade. "By not teaching reading, but instead giving them puppetry, stories, poems, verses, singing games, movement, and gesture, we're building a strong inner reservoir that children can later draw upon when they do learn to read." (Ann Pratt, founder of the Pine Hill Waldorf School in Wilton,

NH). This "inner reservoir" is the core, the heart, intrinsic to learning but largely ignored by most schools and departments of education. The Waldorf schools emphasize what others do not: the fairy-tale magic of being a child. I would like to think that we never lose the wonder, excitement, magic, and spontaneity once we are adults. We are simply too busy to remember, to take the time to "see" what only the heart can know.

Remember the etymology of the word 'courage' is 'coeur,' a French word meaning heart. And perhaps it does take courage in today's high-tech, fast-paced world, to stop and "see with the spirit what the eye cannot behold." I believe that exposure to the world's literary and artistic heritage, and art appreciation in general, is more than an academic area of study; it is an exposure to our inheritance and a part of our very being. Education should, in my opinion, encompass not only the so-called rational mind; it needs to probe the instincts/the non-rational/the intuitive side of the brain/persona. We need to break out of the merely repetitive thought processes of our minds and open ourselves up to *receive* impulses which originate not in our thoughts, perhaps not even in our brain, but in another place where we find/feel the very source of creativity itself.

Most of our lives today are spent in non-creative activities. We organize our day; we perform various jobs; we arrange/prepare/repeat/contrive this and that. But in that ten percent left, not even the whole ten percent is spent creating/inventing/changing existing patterns. Creativity is not a valued commodity today. I find this particularly upsetting.

"Children have the capacity to 'absorb' culture ..." according to Maria Montessori (1870–1952). The first woman to become a physician in Italy, Maria Montessori did not initially dedicate herself to what was then considered a 'woman's job,' education. Specializing in psychiatry and pediatrics, she concentrated on scientific data as

any man in her field would. In 1901, Montessori's focus changed. She was appointed Director of the new Orthophrenic School that was attached to the University of Rome. Formerly an asylum for "deficient and insane" children, it was an environment that stimulated her to do a meticulous study beginning with all the research previously done on the education of the mentally handicapped. Taking a scientific approach to education, Dr. Montessori pursued her work with objectivity basing her conclusions on observation and experimentation. Eventually she retired from the medical profession and dedicated herself to advocating the rights and intellectual potential of all children.

"[E]ducation is not something which the teacher does, but it is a natural process which develops spontaneously in the human being," Dr. Montessori wrote in a 'house for children' from *The Absorbent Mind*. The two key words to me in the work of Maria Montessori are: 'spontaneously' and 'absorbent.' Her research and the study of education in general is not just about children; it is the study of humans as a whole, of our culture and our potential. Although Dr. Montessori was acknowledged as one of the world's leading educators, the implementation of her approach to learning has not been as widespread as one would hope. Only in recent years has her work been reevaluated and recognized by psychologists and developmental educators as not only insightful but clearly ahead of its time.

Many new theories of education are evolving today as we become aware of the significance of a holistic approach to learning. Knowles, Senge, Schmid, Lozanov, Gardner, Fuller, and Diamond are among the 'new' researchers in the development of so-called 'Accelerative Learning,' a method which is supposed to generate higher levels of thinking and creative problem solving. The term 'Accelerative Learning' was first introduced by Lozanov's followers in the United States in 1975.

Dr. Georgi Lozanov was a Bulgarian psychiatrist. In his late thirties, Dr. Lovanov was already a famous man having cured patients from many strange psychic problems. He was also a leading parapsychologist. He believed that our psychic capacities surpassed everything we had achieved in our evolution as human beings. [I am reminded that it was Teilhard de Chardin who believed that the so-called Darwinian evolution of the species actually continues in the mind of man developing into what he, a Jesuit condemned by his own Church, called the *noosphere*. It is no wonder then that so many so-called 'new' theories are popping up all over the world proclaiming the same truisms about the human mind and its potential for learning and the great need for creativity research!]

In 1965, Lozanov went to India to study the psychic capacities of the Yogis. He found that some of the Yogis not only had unlimited capacity for memorizing data, but they also had an almost totally photographic memory. As a result of these findings, Dr. Lozanov developed a new form of learning. Putting his students in a comfortable environment, stretched out in comfy armchairs, he played music by Bach or Handel while he or another teacher recited entire phrases in a foreign language. The tone of the teacher's voice varied in synch with the rhythm of the music. The results of this new theory of learning were seemingly incredible. In two or three months, students were allegedly able to learn difficult languages like Chinese or Russian. No grammar was taught. Dr. Lozanov believed that our subconscious mind knows all the grammars of all the languages of the world. It was his belief that his students were placed in the *alpha* state making them receptive to the language. The alpha state is typically the state of our brain between sleeping and waking. Some scientists tell us that it is in this state and only in this state that the two hemispheres of the brain are in harmony and "function in *mutual interdependency,* thus reaching the full potential of creative

possibilities we dispose of." (Ch'i Genics Research) The learning process can almost be described as learning by absorption! The music acts as a kind of transmitter. In 1966, Dr. Lozanov first published the term, 'Suggestopedy,' in Bulgarian and, in 1967, in English at an international conference on psychosomatic medicine which was held in Rome. In 1976, Dr. Lozanov contributed to a contemporary accelerative method of learning, but further scientific inquiry into the 'reserves of mind' led him to what he called 'Desuggestive Mental Training.'

Then let us look again at Father Pierre Teilhard de Chardin's theories and philosophy. Teilhard de Chardin was born in 1881 in Auvergne, France, the son of a gentleman farmer whose interest in geology he came to share. When he was eighteen, he became a Jesuit and thirteen years later, he was ordained (1912). World War I broke out and the newly ordained priest chose to be a stretcher-bearer rather than a chaplain. He was awarded the Legion of Honour for his courage on the battle lines. In 1922, he graduated from the Sorbonne with a Ph.D. In 1923, Father Teilhard de Chardin traveled to China on his first paleontological and geologic mission. He participated in the discovery in 1929 of the Peking man's skull, a clue to the so-called 'missing link.' His writing at this time reflects his desire to combine his fascination with paleontology and geology with his life's work as a theologian. He wrote about the evolutionary process and viewed the universe and humanity as equal partners in that process, a kind of metaphysics of evolution. "Teilhard regarded basic trends in matter, gravitation, inertia, electromagnetism, and so on as being ordered toward the production of progressively more complex types of aggregate. This process led to the increasingly complex entities of atoms, molecules, cells, and organisms, until finally the human body evolved, with a nervous system sufficiently sophisticated to permit rational reflection, self-awareness, and moral responsibility. Teilhard de Chardin argued that the appearance of man

brought an additional dimension into the world. This he defines as the birth of reflection: animals know, but "man knows that he knows." He further states that the next step in the evolutionary process as it regards mankind is social. "The Age of Nations is past. The task before us now, if we would not perish, is to build the Earth." Anticipating James Lovelock's 'Gaia Hypothesis,' Teilhard de Chardin's writing reflects his concern for and respect of the earth as an autonomous personality.

Most of Teilhard de Chardin's writing was condemned by the Church and he was forbidden to teach in his native France. He returned to China and worked for many years before being made the director of the Laboratory of Advanced Studies in Geology and Paleontology. However, the Second World War broke out and he was imprisoned by the Japanese for six years. When he finally did return to France in 1946, he was again forbidden to publish any more of his philosophical work. So he moved to the United States and worked at the Wenner-Gren Foundation in New York City. It was under this foundation's auspices that Teilhard de Chardin made two paleontological and archeological expeditions to South Africa. He died in New York in 1955 and is buried next to the Hudson River, in the state of New York.

When his writings were published after his death, they were met with both widespread interest and controversy. I was a student at the Catholic University of Louvain in Belgium in 1963–1964 and remember the University's stance against his work. Of course, since it was forbidden, we students all read whatever we could find!

Then there is Antoine de St. Exupery, pilot and author of *The Little Prince* (*Le Petit Prince*) who shared his own secret: "It is only with the heart that one can see rightly; what is essential is invisible to the eye." Thus we return the pinnacle on which all these philosophies and movements depend: *coeur* (heart) = courage.

It is not our heads or our bodies which we must bring together,
but our hearts…. Humanity … is building its composite brain
beneath our eyes. May it not be that tomorrow, through the logical
and biological deepening of the movement drawing it together,
it will find its heart, without which the ultimate wholeness of its
power of unification can never be achieved?"

Teilhard de Chardin

What Rudolf Steiner's instructors teach in the Waldorf schools is to learn "to see with the spirit what the eye cannot behold," where man, 'the soul-bearer,' "gives the spirit a place to dwell;" a school where the graduates believe in the orderliness of our universe. Does this not reflect the philosophy of Teilhard de Chardin? And the modern movements in theories of education and the learning process, do they not reflect the sense of oneness, a convergence on the planet and with the planet anticipated by Teilhard de Chardin? And the spontaneity and 'absorption' of educational material which Maria Montessori considered 'natural' to all human beings, does this not reflect the present evolutionary stage of humanity? Further, does not the fact that we have the ability to 'absorb' information as proven by Lozanov not convince us of the so-called other dimension, namely: the creative urge?

Technological progress is being made all over the world. But another avenue of progress is also being made all over the world and that is the progress of research in the field of creativity. It cannot, and should not, be ignored that the creative endeavor has a spiritual side to it. Inspiration is a key factor and its roots may not be as nebulous as they first appear.

We can learn from the past to prepare for a better future. Raymond Greiner gives us a taste in the following:

Human social design has traveled a long, meandering path encountering a myriad of challenges, barriers and conflicts. History unveils an assortment of achievements, errors, and misdirection resulting in what is perceived as the modern era.

Observing historic individual achievers, we learn money was often a minor player. Van Gogh was inspired by art, and received no payment for his efforts; yet, is considered among the greatest artists. Einstein supported himself on a modest professor's salary. Spiritual teachers and sages uniformly embrace ascetic philosophies. Greatness frequently emerges outside the influence of monetary power and ambition. Inspiration is heart driven, and may or may not be altered by fiscal power.

Remember, genuine creative imagination does not just spring from the right hemisphere of the brain. Nor does it require analysis and monetary support.

There is a relationship between scientific innovation and the humanities. And the humanities, including history, philosophy, and literature, emanate from the creative urge. In fact, philosophy (one of my favorite humanities) is where most of us live most of the time. And for the scientist, without the free roaming of imagination, he or she would never 'discover' new things and ideas. Einstein could not have formulated his theory of relativity without imagination. Yes, he had the basic formulae down pat. But it was the free roaming of his dreaming mind which allowed him to come up with insight and, consequently, his theory of general relativity. (His theory predicted that the space-time around Earth would be not only warped but also twisted by the planet's rotation). Dr. Einstein wrote:

Creating a new theory is not like destroying an old barn and
erecting a skyscraper in its place. It is rather like climbing
a mountain, gaining new and wider views. Discovering the
unexpected connections between our starting point and its rich
environment.

That creativity is essential for science is a relatively new concept. In 1901, Joseph Conrad, in a letter to the *New York Times,* wrote, in his opinion science is "not concerned with truth at all, but with the exact order of such phenomena as fall under the perception of the senses. Its conclusions are quite true enough if they can be made useful to the furtherance of our little schemes to make our earth a little more habitable. The laws it discovers remain certain and immovable for the time of several generations." Anything goes as long as the formula works. Referring to the sphere of art, Conrad stated, "[T]he only indisputable truth of life is our ignorance. Besides this there is nothing evident, nothing absolute, nothing uncontradicted: there is no principle, no instinct, no impulse that can stand alone at the beginning of things and look confidently to the end." For Conrad, the two realms of art and science were irreconcilably contradictory. For him, fiction demanded a "spirit of scrupulous abnegation. The only legitimate basis of creative work lies in the courageous recognition of all the irreconcilable antagonisms that make our life so enigmatic, so burdensome, so fascinating, so dangerous, so full of hope." The mysteries of the imagination spurn categorization and formulas.

Whilst developing creativity,
Also cultivate receptivity.
Retain the mind like that of a child
Which flows like running water.

The Mystery

When considering any thing,
Do not lose its opposite.
When thinking of the finite
Do not forget the infinite.

<div align="right">Tao poem</div>

Remember the greatness of a creative work is not what it says or what it describes. The greatness lies in a writer's unique interpretation or vision. "Within each of us is a creative core that actively creates the universe." (Robert Hand)

And consider the following written by a lady who could not see, could not hear, could not speak, but wrote:

The best and most beautiful things in the world cannot be seen or even touched – they must be felt with the heart.

<div align="right">Helen Keller</div>

Go choose a special place. Sit still and just 'be there' before you begin to write. When you are ready, write everything you can about this place. Make the reader see it, feel it, smell it, and even taste it the way you do. Let your mind wander. Perhaps memories will float across as you relax. "Let the hands of mem'ry weave, The blissful dreams of long ago." (George Cooper) Give yourself permission to tell more about yourself.

Though we travel the world over to find the beautiful, we must carry it with us or we find it not.

<div align="right">Ralph Waldo Emerson</div>

8

More Music

I thought of myself as like the jazz musician: someone who practices and practices and practices in order to be able to invent and to make his art look effortless and graceful.

Toni Morrison

According to the late Pulitzer Prize winning columnist William Raspberry, the rules and the music of language are two of the most important lessons a student can learn. But even more important is the recent finding that music has a physical effect on children's brains. Music not only helps children develop fine motor skills, it also aids emotional and behavioral issues. Plus attention skills were enhanced and accelerated when a child was trained on an instrument. This is all from recent research conducted in January 2015 at Vermont College of Medicine.

The music of India has no beginning and no end. Music represents a plane of consciousness. It is going on all the time. Rhythm, meter, and movements are instruments of art. To hang on, halt or cling to a moment in time is to disobey the rules of nature, the laws of existence, and the essential rhythm, which is life itself.

Music is motion; life is motion. The challenge to the writer is to attempt to capture motion through the medium of the written word, which will remain static on paper. A well-known writer once told me that sometimes when she was writing, the music of the words she was trying to shape and gather would take her far beyond the words

themselves. "I am aware of a rhythm, a dance, a fury which is as yet empty of words," she said. In music, there are no appearances, no forms. If this happens when you are writing, stop and be present where you are and to what you are doing. Find your own rhythm and balance, your voice and beat. The writing will come.

Toni Morrison, in an interview with Paul Gilroy, stated, "Black Americans were sustained and healed and nurtured by the translation of their experience into art, above all, in music...." Certainly, Ms. Morrison, winner of the Pulitzer Prize for Literature, has captured the essence of black culture in her writing. Read her writing aloud. Toni Morrison writes the way she hears the black voices. The structure, texture and tone sound like the indigenous and intrinsic nature of the black people she is writing about. After all, African Americans came from an oral tradition of storytelling and song.

> [I]t is only the story that can continue beyond the war and the warrior. It is the story that outlives the sound of war-drums and the exploits of brave fighters. It is the story ... that saves our progeny from blundering like blind beggars into the spikes of the cactus fence. The story is our escort; without it we are blind. Does the blind man own his escort? No, neither do we the story; rather it is the story that owns us and directs us.
>
> Chinua Achebe, *Anthills of the Savannah*, 1987

Modern African novelists, like Chinua Achebe above, often introduce oral stories (song-tales, myths, folklore) into literature. However, oral tradition is not confined to Africa. Perhaps ninety percent of the *New* Testament is based on authoritative oral tradition. Native Americans continue traditions based on oral history passed down through the generations.

Another common attribute is the Native American belief that generally, words are thought to have a force which is related to their specific sounds. Basically, words are not considered as symbols for reality, but rather as forces themselves. Since the breath is identified with the principle of Life, and since words are spoken with the breath, words are considered sacred and must be used with care. Also, since words are considered forces, it is thought that the spoken word can have a direct affect upon the natural world. This idea is similar to the concept of magical incantations and the use of mantras. Native Americans are not the only ones who consider sound or vibration as a creative force. Consider this quote from the Holy Bible. The gospel according to Saint John (Chapter 1 verses 1–4) puts it this way:

> *In the beginning was the Word, and the Word was with God, and the Word was God. The same was in the beginning with God. All things were made by Him; without Him was not anything made that was made. In him was Life; and the Life was the Light of Men.*

The "Word" or Logos is an ancient Greek concept. It is basically the idea that everything manifests through vibration. Furthermore, ancient Greeks believed everything came into existence by a sacred Word spoken by God. Actually, at the molecular level, everything is vibrating. Furthermore, if a note is intoned at the proper pitch, a glass or other object will shatter, thus proving that sounds are forces. So the American Indians and the Ancient Greeks may be right. Elsewhere, a study is being conducted on the oral traditions among ethnolinguistic groups in eastern Indonesia (East Nusantara Linguistics). In fact, there are more than one hundred oral traditions being researched (and thus continued) today.

Let us see how we as writers and historians through tales of our own lives might incorporate the oral tradition into our writing. "To make the story appear oral, meandering, effortless, spoken, to have the reader feel the

narrator without identifying that narrator … and to have the reader work
with the author in the construction of the book … is what is important."
(Toni Morrison) Music and reader participation, these are two parts of the
equation for a well-written story or novel. There is a certain affinity between
musical rhythm and literary rhythm. The choice of so-called beat or pattern
relates to content or the vision of the author. The sounds in literature are all
connected with intellectual and emotional meanings.

Read the following passage by Ernest Hemingway out loud. Notice
the cadence, the darks and lights, the alliteration emphasizing the
soothing quality of the passage:

> *He lay flat on the brown, pineneedled floor of the forest, his chin*
> *on his folded arms, and high overhead the wind blew on the tops*
> *of the pine trees. The mountainside slipped gently where he lay;*
> *but below it was steep and he could see the dark of the oiled road*
> *winding through the pass. There was a stream alongside the road*
> *and far down the pass he saw the mill beside the stream and the*
> *falling water of the dam, white in the summer sunlight.*

Hemingway's work is deceptively simple using active verbs and
nouns. Most of the adjectives come from the reader as he or she ingests
the work. With the minimum of words, Hemingway could convey a
view, a mood, and a place:

> *I heard and felt the canvas move as the man on the stretcher settled*
> *more comfortable.*
> *'How is he?' the Englishman called back.*
> *'He's dead I think,' I said.*
>
> Hemingway, *A Fairwell to Arms*

Startling, isn't it! Few words, but full of emotion, the readers' emotion.

In the following paragraph, attention is given to all the senses except sound, for this is a quiet place. Notice the repetition and the unusual metaphor ("the logs ... gray to the touch").

> *He sat on logs, smoking, drying in the sun, the sun warm on his back, the river shallow ahead entering the woods, curving into the woods, shallows, light glistening, big water-smooth rocks, cedars along the bank and white birches, the logs warm in the sun, smooth to sit on, without bark, gray to the touch; slowly the feeling of disappointment left him.*
>
> The Two-Hearted River, Part II,
>
> a short story written for a magazine in 1925

As the river flows, the reader feels drawn into the scene, lured as if he were being reeled in by the man's fishing rod. Then notice how, after the semicolon, we are back with the protagonist. It is he who is feeling better in his temple of peace. The river itself here (and in most literature and myths) represents transformation, rebirth, and enlightenment for the person who attempts to cross it or enter it. This is an example of motion in stasis (see page 11). The writer arrests motion (life) and arbitrarily chooses a moment in time in which to focus the story. Choosing a moment (in time, an artificial means of demonstrating motion itself) is as paradoxical as life itself. Faulkner's work best illustrates this notion. Consider the following imagery in *As I Lay Dying:*

> *It is as though the space between us were time: an irrevocable quality. It is as though time, no longer running straight before us in a diminishing line, now runs parallel between us like a looping string, the distance being the doubling accretion of the thread and not the interval between.*

Time here is spatial, not linear. The space referred to above is a river

(remember the transformational experience?). Clearly, this passage represents motion in stasis. Time stops and the reader is invited to "come see." The essence of good writing style is exhibited here, a perfect example of consideration for the reader.

Instead of a writing assignment, I invite you to read Toni Morrison, William Faulkner or Ernest Hemingway. Read their words for the music. Read passages aloud. See if you feel as if you are part of the story. Look for the two elements: of music (literary rhythm) and reader participation.

9

Analogy of Painting

*Under this fine rain I breathe in the innocence of the world.
I feel coloured by the nuances of infinity. At this moment I
am one with my picture. We are an iridescent chaos... The
sun penetrates me soundlessly like a distant friend that stirs
up my laziness, fertilizes it. We bring forth life.*

Paul Cézanne

I dream my painting, and then I paint my dreams.

Vincent van Gogh

Georgia O'Keefe said, "Still – in a way – nobody sees a flower – really – it is so small – we haven't time –and to see takes time, like to have a friend takes time."

An artist never paints 'things'. The artist paints relationships. He or she chooses a center of interest and then considers colors and their values. Cool and warm, dominance verses subordinate. Henri Matisse said: "Color was not given to us to imitate nature. It was given to us to express our own emotions."

The writer should also consider the elements of design. Call it "effective visual paragraphing." According to Leonardo da Vinci: *"Painting is poetry which is seen and not heard, and poetry is a painting which is heard but not seen."*

Yes, poetry and painting are both arts which seek to join man

and his surroundings. The writer can learn from the painter and visa versa. Consider, for example, the work of Gertrude Stein. Living in Paris between the wars, Miss Stein was in the midst of a revolutionary movement called Surrealism. Based on the work of André Bréton, these surrealist artists emphasized the role of the unconscious in creative activity. But *surréalistes* were not only artists. They were authors and poets as well. Paul Valery, a French poet, essayist and philosopher considered all things as part of a single whole. Nothing is casual, he said. Nothing is alone. The independence of objects is only an appearance. Gertrude Stein, using this method, said she did not go after words, but let the words "come to her." Look at Picasso's artwork and the same thing happens.

Like Gertrude Stein, Picasso's original approach to art defied all conventions of the past (although he had already become a master of realistic painting when still in his teens in Spain). Unlike Stein, Picasso did not write but he 'spoke' with his artwork. Nonetheless, Picasso did have one liners which are memorable. An example: "Art is a lie that sometimes tells us the truth."

"One must never forget," wrote Gertrude Stein about Picasso in 1938, "that the reality of the twentieth century is not the reality of the nineteenth century, not at all, and Picasso was the only one in painting who felt it, the only one." She continues, "Picasso was the only one in painting who saw the twentieth century with his eyes and saw its reality and consequently his struggle was terrifying, terrifying for him and for the others, because he had nothing to help him, the past did not help him, nor the present, he had to do it all alone … ." After 'playing' with painting, drawing, etching, lithography, wood and metal sculpture, Picasso, in 1946, discovered clay. Again he defied all conventions and brought fresh energy into the craft of ceramics. For Picasso, although it happened

late in his life (he was born in 1881), this was just one more example of his unique creativity, "sculpting, modeling, and painting new shapes on traditional forms, transforming them with his metaphoric magic." (Suzanne Harper, Director of Art at the Museum of Arts and Sciences, Macon, Georgia) Or as Picasso himself said, "When I was a child, I could draw like Raphael. But it took a lifetime to draw like a child."

Vincent Van Gogh, the son of a Protestant pastor in Holland, believed he also had a religious vocation. However, after working as a missionary in the slums of London and the poor mining districts in Belgium, he left this endeavor and turned to art. It was when he had just realized his need, his desire, to commit to painting, he felt, through his painting, he could communicate his experience "of a world illuminated by God's love...." He wrote to his brother Theo: "Nature always begins by resisting the artist, but he who really takes it seriously does not allow that resistance to put him off his stride; on the contrary, it is that much more of a stimulus to fight for victory, and at bottom, nature and a true artist agree. Nature certainly is 'intangible', yet one must seize her...." Van Gogh was committed to *dégager* (seize from) nature the spiritual aspect or significance, and share this 'reality' with others. In his view, this was the artist's responsibility. So the 'calling of the artist' is to share that insight. In nature, Van Gogh said that he discovered "l'éternelle." Blaise Pascal (1623-1662) understood this. He wrote: "Nature is an infinite sphere of which the centre is everywhere, and the circumference nowhere."

Van Gogh used color in his paintings to express something internal. Talking about his use of color, he said, it is "not locally true from the point of view of the stereoscopic realist, but color (suggests) any emotion of an ardent temperament." Look at and study 'The Artist's Room at Arles' painted in 1888. The painting is less a portrayal of his room than a calculated analysis of an emotional experience. It is a study

of complementary colors, blue and yellow, magenta and green, crimson and yellow. (This painting might also be considered a good example of subtractive synthesis when pigments 'color' by taking away colors). Van Gogh was moody and temperamental as well as deeply religious and his artwork reflects this. He used thick impastos with paint applied directly from the tube. With his enthusiasm and impulsive nature, Van Gogh completed some of his paintings in a single afternoon.

His bright yellows represented love and faith; his blues, especially cobalt, he qualified as 'divine'. If we look at a recent scientific explanation of the color blue, we might find Van Gogh was closer to the correct definition of blue than he would have ever imagined.

Blue is fascinating because the vast majority of animals are incapable of making it with pigments. As it turns out, animals have a lot of color limitations. Browns and grays appear frequently among birds, for example, and they can make yellow and red from pigments they get from their food. But other colors – blue especially – are surprisingly tough for a bird's body to create via dietary pigments, according to Rick Plum, Professor of Ornithology, and Head Curator of Vertebrate Zoology at the Peabody Museum of Natural History at Yale University. The reason why is still a mystery. "Blue is fascinating because the vast majority of animals are incapable of making it with pigments," Richard O. Prum, stated in an interview on NPR (National Public Radio) 'Morning Edition.' In fact, of all Earth's inhabitants with backbones, he explained, not one is known to harbor blue pigment. Even some of the most brilliantly blue things in nature – a peacock feather, or a blue eye, for example – don't contain a single speck of blue pigment. So, how can they look so blue? "They have evolved a new kind of optical technology, if you will, to create this color," Prum explains. "It's a trick of structure…. Everywhere you look, organisms have been inventing different solutions to creating the same color," added

another scientist, Antonia Monteiro, who studies butterfly wings in Singapore. "Structural color," he explains, "isn't just a hack for making blue. It's also a hack for lasting through time."

The best example, they said, might be a 50-million-year-old beetle carcass found in Germany in 1998. It was down in a layer of dull brown and gray fossils. Even after millions of years underground, this particular beetle was still a brilliant, metallic blue. So Van Gogh's representation of blue as divine takes on a whole new meaning in light of this study.

As for Van Gogh's other choices of colors? For him, reds and greens represent passion. But consider also the symbolism of mixed (as opposed to pure) colors like orange. Orange promotes conversation and encourages spirituality. Green (blue and yellow) symbolizes relaxation as well as change. Green encourages growth and feelings of tranquility and awakening. It was with color that Van Gogh attempted to "save others," to "stay the desperate and console the lonely." He considered each of his paintings as a symbolic equivalent of his own experience, which, he hoped, would lead the spectator to a more profoundly spiritual understanding of life. Translate this philosophy into poetry and we have a poem by Walt Whitman:

> *Give me the splendid silent sun, with all his beams full-dazzling;*
> *Give me juicy autumnal fruit, ripe and red from the orchard;*
> *Give me, odorous at sunrise a garden of beautiful flowers, where I can*
> * walk undisturbed....*
> *Give me solitude and give me Nature and give me again, O*
> * Nature, your primal sanities!*

Van Gogh was a primary influence on Henri Matisse who also used crimson, yellow, blue, and green. But with Matisse's work, the paints are not thick. They are applied in an almost watercolor-like fashion.

"Color was not given to us to imitate nature," he said. "It was given to us to express our emotions." But he too could have walked through Whitman's garden at sunrise and observed the colors in nature allowing them to speak to him emotionally. Then taking these emotional views of color, he would translate them to reflect his own temperament with a paint brush. It is also interesting to note his use of black in some of his paintings. "I am now using black as a color of light," he said.

Prepare to clear the crowded mind
to find an open, empty space
in tune with time's irrelevance
and there embraced by dark of night
be ready to rejoice in black
the dazzling color of light.

Elinor Roberts Hartt

Renoir, who detested black and never used it, had to admit in a letter to Matisse that he respected him for his ability to "put black on the canvas [and] it stays in place.... It is a tint I have banished form my palatte. As for you, using a colored vocabulary, you introduce black and it holds. So, in spite of my feeling, I think that you are most surely a painter." But it was Paul Cézanne who told Matisse, "One must construct." To which Matisse replied, "Certainly, but with color." Of course, Cézanne agreed. As we shall see, Cézanne proclaimed, "When color is at its richest, form is at its fullest." The blue was used, he said, "to make the air felt." What fascinated Matisse was the capacity of blue to function three-dimensionally as well as two-dimensionally.

Paul Cézanne (1839–1906) is generally accepted as representing the first 'modern' artist. It was Cézanne who was the first to attempt to clear away the cobwebs of the past ideologies of Classicism, Romanticism, and Naturalism. He also broke away from the realism of the impressionists

whom he viewed as artists attempting to capture what the eye sees in a moment in time, like a camera. Instead, Cézanne wished to capture the continuous fluxuation that is life. To which he added, "One must not imitate the sun; one must become sunlight." To achieve this goal, Cézanne attempted to paint the atmosphere and, therefore, the movement, into his landscapes. Keep in mind light and shadow never stand still. Cézanne was one of the first generation of painters to go outdoors and paint en plein air; that is, on location. To help, science had by this time invented synthetic paints which fit into a tube and which could be transported quite readily.

Often in his correspondences, he spoke of his "realization" in art. It is a term of central importance in his conception of a goal for his work. "Studying the model and realizing it is sometimes very slow in coming for the artist," he wrote in 1904. Never daring to trust his 'acquired' knowledge, Cézanne felt "the conviction behind each brush stroke" had to be won from nature at every step. What he was hoping to accomplish was to bring together the viewed and the viewer. "I am still searching for the expression of those confused sensations that we bring with us from birth." His paintings reflect not only what he observed but also the atmosphere and the emotions he, the artist and the observer, felt while observing.

In the painting below completed in his studio in Aix-en-Provence (c.1890), Cézanne has spread out a basket of fruit, his favorite ginger jar, and various other things on a white tablecloth. All of these items are perched at various angles on a wooden stool.

Still Life with Ginger Jar Paul Cézanne

However, the stool isn't contoured correctly nor is the ginger jar looking secure. The angle of the basket does not relate to the angle of the jar. The whole scene is precarious and if we didn't know better, we would think this artist had not learned about perspective. Certainly this still life does not depict these objects realistically as they appeared in his studio. Or do they? The guide who took me through Cézanne's studio in 1994 explained that Cézanne was attempting to place the viewer in the painting with the viewed. In other words, the position of objects was determined by the way they looked as he, the artist (and thus we, the viewers), walked around the stool. His movement determined the contour and angle not only of the objects but the stool as well. Wassily Kandinsky in *On the Spiritual in Art* wrote about Cézanne's still-life: "He made a living thing out of a tea cup.... He raised the 'nature morte' to a height where the exteriorly 'dead' object becomes inwardly alive."

In his landscapes, Cézanne desperately wanted to bring to his canvases certain vitality, a force, a direct and personal expression to what he was seeing before his eyes. Bringing form and color together into a coordinated harmony was essential (remember Joyce's *consonantia?*). But to achieve this harmony, Cézanne realized he could not rely on his vision alone. His sensations were the key. This took him away from a static look at a mountain or quarry or whatever his subject was and led him into a kind of dialogue or dynamism with the atmosphere of the place and himself, the painter, just as he had created the movement around the table.

> *[T]reat nature by the cylinder, the sphere, the cone, everything in proper perspective so that each side of an object or plane is directed toward a central point … nature for us men is more depth than surface, whence the need of introducing into our light vibrations, represented by reds and yellows, a sufficient amount of blue to give the impression of air.*

For Cézanne, "the ultimate synthesis of a design was never revealed in a flash; rather he approached it with infinite precautions, stalking it, as it were, now from one point of view, now from another, and always in fear lest a premature definition might deprive it of something of its total complexity." (Roger Fry, *Cézanne, A Study of His Development*, 1927) We feel the pulsating energy of his strokes as he superimposes color on color and feel the reverberation of each new touch, a mental operation that was compared by Walter Pach to a musician "whose material … arrived much sooner at its purity as an agent of expression."

Form in the long run ended up taking precedence over color for Cézanne. It became painful for him to eliminate or modify the physical structure of objects, yet he continued on this path "making a constantly more rigorous elimination of the sensations which to him represented

only accidents of vision and which were not essential to the new organism he was building up."

Cézanne returned again and again to view Mont Sainte Victoire. He observed the play of light on the mountain and on the leaves in the trees, in the sky and on the clouds. Everything was in motion and the light epitomized this motion. Cézanne painted rapidly forming small shapes of color to represent movement. The perspective recedes and shifts as he refocuses on the view. In fact, he spent his entire life attempting to render the atmosphere, the way he as an individual saw what he saw; he explored with intense scrutiny every kind of linear direction, the capacity of planes to create depth, the intrinsic qualities of color. His search was a way to render reality not as mere appearance but as essential reality in the philosophical sense.

This view of Cézanne's work takes the artist to a different level. It sees his work as something that developed apart from the artist and yet not really. For it was the artist's decision to eliminate this and that form or line and allow the painting to take on a soul or spirit of its own. It was the call of the abstract conflicting with Cézanne's devotion to nature.

This dilemma is similar to a writer allowing the words to take over and dictate what they wish to express. You, the writer, almost stand by and watch in awe even though you know what is written all comes from you and your relationship to what is 'out there.'

In 1907, Rainer Maria Rilke wrote from Paris, apropos Cézanne:

> *Ideally a painter (and, generally, an artist) should not become*
> *conscious of his insights; without taking the detour through*
> *his reflective processes, and incomprehensibly to himself, all his*
> *progress should enter so swiftly into the work that he is unable to*
> *recognize them at the moment of transition.*

Ultimately, however, Cézanne believed he could never reach his self-imposed goal and even wrote in his diary that it would be for the next generation of artists to discover. "I was the painter of your generation more than my own," he said to a young painter. This was his thought, in part his discouragement, toward the end of his life. Loneliness and dedication to his work defined Cézanne as he sought and searched for a means of expressing his emotion. "Do not be an art critic," he wrote to Emile Bernard, "but paint–therein lies salvation." And later, in 1905: "Time and reflection, moreover, modify little by little, our vision, and at last comprehension comes to us."

And indeed, Cézanne did prepare the way for the next artistic movement to reach the art world: the cubists. Suddenly, to the two-dimensional canvas, a new dimension was added. Depth and distance had already been achieved and Cézanne had attempted movement, at least in terms of the artist's participation, but now a more complex temporal dimension was being added. This temporal dimension represented both the physical and psychological aspect of movement. Objects appear not as they are at any given moment in time, but as they are seen from different moments in time and/or from varying emotional aspects.

Study Duchamp's painting, *Nude Descending the Staircase* completed in 1912. Moments of movement are captured on one canvas. Not only the movement, but the element of time is also captured. Compare this artistic form to James Joyce's concept of aesthetic arrest: 'stasis'.

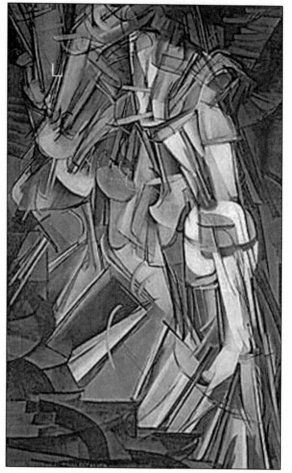

Nude Descending the Staircase Marcel Duchamp
© 2005 Artists Rights Society (ARS), New York /
ADAGP, Paris / Succession Marcel Duchamp

Another interesting literary comparison is *Absalom, Absalom!* by William Faulkner. Here Faulkner also creates the effect of seeing a situation from many different perspectives. This assemblage not only denies any one claim to absolute truth but also allows or forces the reader to search for something else which, at the very least, might approximate the truth. Like cubism, the narration is arranged and patterned on different levels. As we observed in the prior chapter (More

Music), Faulkner's novels are spatial as opposed to linear constructions. Like the Cubists, Faulkner brings together different perspectives of an event and the reader/viewer is left having to decide for him or herself what the true reality is. In the paintings, the forms are taken apart to be reassembled by the viewer; the same holds true for Faulkner.

> *Maybe nothing ever happens once and is finished. Maybe happen*
> *is never once but like ripples maybe on water after the pebble sinks,*
> *the ripples moving on, spreading the pool attached by a narrow*
> *umbilical water-cord to the next pool which the first pool feeds, has*
> *fed, did feed, let this second pool contain a different temperature*
> *of water, a different molecularity of having seen, felt, remembered,*
> *reflect in a different tone the infinite unchanging sky, it doesn't*
> *matter; that pebble's watery echo whose fall it did not even see*
> *moves across its surface too at the original ripple-space, to the old*
> *ineradicable rhythm thinking Yes, we are both Father.*
>
> R. William. Faulkner, *Absalom, Absalom!*

Faulkner's novels are not easy to read. The above quote, after all, continues, viewing and reviewing and deciding and decoding until finally resolving with a period at the end. Nor were the novels easy to write according to the author himself. He once compared writing a novel to "trying to nail together a hen house in a hurricane." So take heart, dear reader, writing and writing well is difficult even for the best.

"A work of art must carry in itself its complete significance and impose it upon the beholder even before he can identify the subject matter." This was written by Henri Matisse in 1908 in his *Notes of a painter.* "The whole arrangement of my picture," he continues, "is expressive. The place occupied by figures or objects, the empty spaces around them, the proportions, everything plays a part." Think about

these words in terms of writing. Everything plays a part. Even what is not said, what is not described. What is inferred or suggested is equally important.

The canvas has its limitations, the most obvious of which is its being two dimensional. The painter must attempt to create the three-dimensional reality on a two-dimensional surface. "But what of the moderns?" you may ask. There is a story passed down by students at an art school established in the 1930s in the Blue Ridge Mountains of North Carolina. Willem de Kooning, an already well-established avant guard modernist (a member of a group in New York who called themselves Abstract Expressionists) was to conduct a course. All the young students wanted to be in this great man's class. They wanted to learn how to paint abstract art. 'Professor' de Kooning let their passions rise as he was a good forty minutes late for the beginning of class. Finally, the great man appeared and with almost reverent, bated breath, they watched as he placed a bowl of fruit on the table in the middle of the classroom. "This," he announced, "is what you are going to paint." More than astonished, half the students were disgusted and left. After all, a bowl of fruit was generally the subject for beginning classes. Mr. de Kooning waited for their departure, cleared his throat and, to the remaining students, he continued, "You will paint this bowl of fruit until it is really there, on your canvas." More students left. "And then," he resumed facing the few who remained, "you will paint this bowl of fruit until it disappears!" The students who were smart enough to stay were delighted. Frantically, they began to prepare their canvasses, but, before they could begin, de Kooning had something more to say. "And then," he began, taking a sigh and clearly enjoying the moment, "and then, you will continue to paint the bowl of fruit until it comes back *on its own!*"

Until it "comes back on its own!" James Joyce decribed a similar process in *A Portrait of the Artist as a Young* Man. Stephen Dedalus, the hero, is speaking to a classmate: He points to a basket which a butcher boy had slung inverted on his head.

> *Look at that basket, he said.*
>
> *I see it, said Lynch.*
>
> *In order to see that basket, said Stephen, your mind first of all separates the basket from the rest of the visible universe which is not the basket. The first phase of apprehension is a bounding line drawn about the object to be apprehended. An esthetic image is presented to us either in space or in time. What is audible is presented in time; what is visible is presented in space. But temporal or spacial, the esthetic image is first luminously apprehended as selfbounded and selfcontained upon the immesurable background of space or time which is not it.*

Picasso was also a member of the school of artists that called themselves Cubists. In 1903, Picasso painted a 64 x 51 1/4 inch oil on canvas called *Girl Before a Mirror*. According to the Museum of Modern Art's curator, William Rubin (in 1972), "The balance and reciprocity of the expressive and the decorative here set a standard for all Picasso's subsequent painting – indeed, for twentieth-century art as a whole." (William Rubin, *Picasso* in the Collection of the Museum of Modern Art, New York, 1972, p. 138).

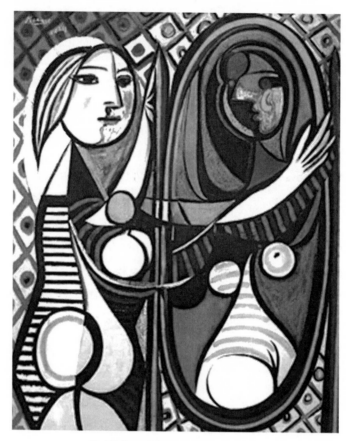

Girl Before a Mirror, P. Picasso, 1932

Let us examine this painting particularly in light of its influence on art in the twentieth-century. The painting depicts a girl who has reached puberty contemplating herself in a full-sized mirror. Her face is at once profiled and frontal. The profile is cool, pale and as smooth as youth itself. The frontal side that depicts the unseen portion of the profile is bright yellow, rouged, red-lipped, and rough. It could be compared to the sun in light of its reflection which is shaped like the moon. White, almost halo-like, appeared behind the hair of the real girl; it does not appear in the reflection. Rather, black and blue shaped crescents surround the girl. In "morbid anticipation of a young girl as she becomes

aware of her biological role in womanhood" the head is followed by a spinal cord and the shapes of her reproductive organs. (Edmund Burke Feldman, *Varieties of Visual Experience*, Prentice-Hall, Inc., Englewood Cliffs, N.J.1981) The girl's arm reaches across with long, tenuous fingers almost growing out of her hand in a gesture that possibly caresses her image (many have suggested the arm represents a giant phallus, an allusion to imminent maturity or loss of virginity). Is it fear of the loss of youth and innocence? Is the artist sympathetic?

Picasso's art spanned three decades and expressed itself in several different styles and mediums: paintings, drawings, sculpture, and graphics. Though this painting was compared to Titian's *Venus with the Mirror*, Picasso was reported to have responded: "The beauties of the Parthenon, the Venuses, the Nymphs, the Narcissuses, are so many lies. Art is not the application of a canon of beauty, but what the instinct and the brain can conceive independently of that canon." Concerning this young woman, he continued, "When you love a woman you don't take instruments to measure her body, you love her with your desires." (Lael Wertenbaker and the Editors of Time-Life Books, *The World of Picasso 1881–*, Time-Life Books, New York, 1967) For the viewer, however, the painting takes on mythic proportions. It invites speculation. It encompasses universal truths. The artist, despite himself, has become philosopher. The dualities of human nature are evoked: the id verses the ego, outer and inner self, the womb and the tomb (life and death), innocence verses corruption. Multiple and contradictory experiences are expressed, all within the confines of one flat canvas.

"As revolutionary as the discoveries of Einstein or Freud, the discoveries of Cubism controverted principles that had prevailed for centuries. For the traditional distinction between solid form and the space around it, Cubism substituted a radically new fusion of mass and void." In place of perspective, "Cubism offered an unstable structure

of dismembered planes in indeterminate spatial positions. Instead of assuming that the work of art was an illusion of a reality that lay beyond it, Cubism proposed that the work of art was itself a reality that represented the very process by which nature is transformed into art." (Robert Rosenblum, *Cubism and Twentieth Century Art.* Harry N. Abrams, Inc., Publishers, New York, 1960) Contradictions and ambiguity dominated this movement.

More and more, the modern artist attempts to abstract from reality. "Cubism did not accept the logical consequences of its own discoveries; it was not developing abstraction toward its ultimate goal, the expression of pure reality," said Piet Mondrian (1872–1944) (Gardner, p.707) Mondrian ended up reducing all shapes to rectangles and squares and using only the primary colors plus black and white. This leads me to include another artist who, despite earlier work depicting beautifully country scenes, evolved into an artist depicting squares.

Only dull and impotent artists screen their work with sincerity. In art there is need for truth, not sincerity.

This was written by Kazimir Severinovich Malevich (1878–1935), the Russian and Soviet avant-gardist artist of Polish origin, teacher, theorist of art, philosopher, and founder of *suprematism* – one of the earliest manifestations of the abstract art. The term *suprematism* refers to an abstract art based upon "the supremacy of pure artistic feeling" rather than on visual depiction of objects. Malevich was derided for reaching art by negating everything good and pure like love of life and love of nature. It was Malevich's opinion that art can advance and develop for art's sake alone, regardless of its pleasure. In his opinion, art does not need us, and it never did. "In 1918, a year after the Russian Revolution, the connotations of this sense of liberation were not only aesthetic but sociopolitical." Malevich expressed his exhilaration in a manifesto published in

conjunction with the first public exhibition of the series in Moscow in 1919. Malevich's explanation was: "I have overcome the lining of the colored sky.... Swim in the white free abyss, infinity is before you." One of his paintings depicts simply a black square in the middle of a white canvas. Initially, the "black square" was used as part of the scenery for the opera "Victory over the Sun" in 1913. It was meant to depict "plastic expression of a victory of active human creativity over the passive form of the nature." The black box appeared instead of a solar circle. Hence, in Malevich's case, art was truly an expression of emotion, attitude. His art became not visual but strictly an internal view of the world around him.

Certainly there are "phases of artistic apprehension" directly related to our view of what is 'out there' and the time we spend absorbing the oscillating transitions of light, shadows, sounds, silence, warmth, cold. So first we see and absorb the image. Second, we investigate how we relate to the image. And third, we writers and artists relate the form for others to see or read, or in the case of music, to hear. For the writer, it may take mountains of papers, hours and hours of writing to come up with one true 'golden' phrase to describe that vision and that moment or as de Kooning says, to allow for the moment when it "comes back on its own." All this we do as creative beings.

> *To express the emotions of life is to live. To express the life of*
> *emotions is to make art.*
>
> Jane Heap

(Jane Heap edited the celebrated literary magazine *The Little Review,* which published an extraordinary collection of modern American, English, and Irish writers between 1914 and 1929. Heap herself has been called "one of the most neglected contributors to the transmission of modernism between America and Europe during the early twentieth century.")

Returning to our journey into the heart of creativity, let us bring art to its latest development: the computer. "A computer monitor displays digital data, dots and colors that are mathematically described and manipulated by microprocessors. When you are looking at a picture on a computer screen, you're looking at an artist's conception (a very fast, accurate artist, a microprocessor) of what happened." New artists are emerging who believe that this 'artificial intelligence', microprocessor, may prove to be the most historically significant event in the history of art. One such artist is Andrew Wysotski of Oshawa, Ontario, Canada, whom I found while surfing the Internet. His letter, or 'statement', reads as follows:

> *When I originally began using the computer, it was only to further develop my oil paintings. This was accomplished by digitizing the paintings into a computer and reinterpreting them. It allowed me to reassess my paintings and create several new versions of each piece. But what was most important to me was the new quality that could be achieved which was unlike any previously pigmented media. All of the paintings that were used as a starting point had a highly personal, humanistic quality about them. However, after being translated through the computer, an interesting contrast and statement was made. The computer images appeared organized, mechanical and untouched by human hands, while just beneath the pixeled surface were the highly romanticized images of the original oil paintings. Presently I am most interested in using the computer to help in the actual creation and execution of a work of art. Hopefully, the computer, for me will become a collaborator in the artistic decision making process.*

The artist within the computer is mathematics pure and simple. The ultimate marriage between art and math has been made. But another aspect of mathematics which also affects the art world is the development of Fractal Geometry.

As we have said, rarely do the exact forms of geometry occur in nature or as we observe natural appearances with the naked eye. A new geometry was constructed in the last phase of the twentieth century which describes nature with shapes of infinite detail like the branching of a river delta as well as nebulous shapes like clouds. What this geometry defines and describes is the property called *roughness*. "Fractals arise in many diverse areas, from the complexity of natural phenomenon to the dynamic behavior of mathematical systems, and their striking beauty and wealth of detail has given them an immediate presence in our collective consciousness. Fractals are the subject of research by artists and scientists alike, making their study one of the truly Renaissance activities of the late 20th century." (Stuart Ramsden, *Fractals, Feedback, and Chaos - a brief history*) A fractal or 'fractional dimension' is the continual repetition of the same or similar features at different scales. As the scale of measurement decreases, the estimated length increases without limit. "Thus, if the scale of the (hypothetical) measurements were to be infinitely small, then the estimated length would become infinitely large! Now in practice we can't keep getting smaller and smaller because sooner or later we hit the grains of sand on the beach or ultimately the atomic constituents of matter. Fractals are abstract mathematical objects, but we can find approximations to them in nature all around us." (David G. Green, ANU Bioinformatics Facility, edited by Dr. Terry Bossomaier, Research School of Physical Sciences and Engineering, ANU) A fractal is also described as being "any curve or surface that is independent of scale. This property, referred to as self-similarity, means that any portion of the curve, if blown up in scale, would appear identical to the whole curve." (ibid) In December 1992, the first Australian Complex Systems Conference was held at ANU. Included in this conference was an exhibition of Complex System Art.

Study the fractal shown here. Think about what this form summons forth or awakens inside of you. Let your mind relax and your thoughts wander. You will be surprised. You might even want to write about what you see and what you do not see.

Nietzsche called the moment of seeing a new view of life the "creative truth." Man is both a creature and creator; it is in his creativity that he glimpses the 'truth' and thus 'truth' is born of observation. "[N]ature is not perfectly rational and does not efficiently fulfill her own longing for perfection." The testimony of the senses leads us to accept multiplicity and change. Our creative mind formulates a system to rationalize and often attempt to duplicate his observations. This system is mathematics. It is at once awesome and beautiful. Mathematics is

truly "what is learned" (*mathema*) and its most beautiful expression is art even on a computer screen and by art we include creative writing.

Longfellow advised: "Give what you have. To someone it may be better than you dare think." So sit in front of your computer and let the words take over. Thinking takes time; enjoy the process, the flow, and the moment of inspiration.

10

Participation

Summoned or not, the god will come.

<div align="right">Motto over the door of Carl Jung's house</div>

I would like to return to the concept of a reader's participation in the novel. Writing is a dialogue, writer to reader. The writer needs to liberate the imagination of the reader. When a story taps into archetypes (universal or 'perfect' types), readers will identify on some level. (The archetype is the creative dimension of our consciousness, according to Carl Jung. It represents the common thread that ties all humanity together. According to Jung, archetypes are intrinsic to man. They have been expressed in one way or another since man first expressed an abstract thought.) The story that best reflects these archetypes is called the myth. Sociologically speaking, a myth may be historical or fictional without altering its nature as myth. This is because the power of myth lies in the meaning and the broader truth it conveys rather than the historicity of the story. The greatest attraction of the myth is its "secret opening through which the inexhaustible energies of the cosmos pour into human cultural manifestation." So began Joseph Campbell in his book, *The Hero With A Thousand Faces*. Since myths are about archetypes, stories and myths from all over the world are very much the same, from ancient times to modern day. Mr. Campbell saw myths as metaphors that "map the possibilities of our development from birth through maturity to old age and death, the possibilities of

our relations with others, the development of nations and cultures, and our relationship to transcendence and the cycles of the cosmos." (John Lobell on Joseph Campbell) In essence, if we are true to ourselves, allowing the words to flow freely, then what will appear on paper will be our own personal mythology.

The etymology of the word 'enthusiasm' is 'of god' or 'god-filled' from *en-theos*. And truly, when something, a fact or an event or another person, touches us in such a way as to speed up our heart, quicken our pulse, it brings us closer to that mysterious part of ourselves, our spirit, our soul, our connection with the divine. To me, myth is the story behind that connection. We connect to the story even though we know it is not true in the factual/scientific sense.

Heraclitus said, "Everything is flux." This is true of the reader's participation in the creative process as well. The exchange between the reader and the written word (ergo the writer's work) can be equated with the constant unfolding of truths from the universe. Good writing can open the eye of the reader's mind, allowing a better, or at least a new understanding of the world and his or her place in it.

> *True wit is Nature to advantage dressed,*
> *What oft was thought but ne'er so well expressed;*
> *Something whose truth convinced at sight we find*
> *That gives us back the image of our mind.*
> *In every work, regard the writer's end.*
>
> Alexander Pope, 1688–1744

Today, perhaps more than any other era, people need the security of knowing there exists an order, a plan, a meaning to life. To find that meaning, we must look inside. Creative writing is the food for the life of the spirit. James Joyce insisted, with some irony, the essence or true substance of

man "consists in his being a conscious reactor against his uncertainty about having any significance." T. S. Elliot had said of Joyce's writing style that it was "a mythical method … making the modern world possible for art…." To Joyce, the aesthetic *was* religion. To quote David Lodge (*The Practice of Writing*), this fusion of art and religion was Joyce's "idea of the quasi-sacramental nature of the artistic process, the mysterious transsubstantiation of quotidian reality into something permanent and transcendent."

An artist is an artist, whether a musician, a painter or a writer. As a foundation, to be even halfway good, every artist needs two basic attributes.

1) Know your medium. We have already spent a good amount of time on the subject of words. Use them. Play with them. Read them to yourself and read them out loud. For example, if a painter is not fully acquainted with his or her medium, he or she will not be able to render the scene, person or object correctly. However, if artists experiment and exercise with the colors, their consistencies, the mixtures, the additives, the brushes, the palette knives, they will be proficient enough and free to be able to paint as the spirit moves them. Knowing these fundamentals, artists will achieve the color, the nuance, the depth, and the consistency they want. In sum, use of the medium will be second nature, instinctual. Only then can their focus be on design. Only then can the creative urge be able to express itself freely. By the same token, if you as a writer do not practice using words, you will not feel comfortable writing and your deep thoughts will not surface. Know grammar and structure first. Study the etymology of words. Feel comfortable with phrases and inferences and analogies.

2) Take the time to notice each thing so each thing gets noticed. Compare looking with seeing. Recognize it as being the same as the differ-

ence which exists between hearing and listening. Write what you see and you will also write what you cannot see. James Joyce said that if we look at any object intensely, that object might become "a gate of access to the incorruptible eon of the gods." In other words, the object will connect with your own experience, your emotional history.

To me, the most valuable aspect of writing, and creative writing in particular, is the process (not the product). If the means is as important as the end. If you reach deep into your imagination and your being, the end will result in a true reflection of you, its creator. The process is the writer's personal quest, forever reaching deep down inside his or her heart. I am, and now you will be, almost always surprised at what comes out, what appears on paper.

The universe is truly both within us and without or outside of us. It can be said that there is nothing new in this world that is not old. All this the artist observes and records be it on paper or on canvas.

Conside the etymology of the word 'aesthetic.' 'Aisthis' with the 'ai' pronounced as a short 'e' means how you see things and differs from one person to the next. Thus, as translated into English, an aesthetic is one who looks at nature and translates it into an artistic form.

Understand being human and understand human beingness.

A spectacular example of the artist being pulled into his or her work by his or her creative muse can be seen in the work and words of sculptress Essie Pinsker. Essie's works in marble, bronze and steel have been acquired by twenty-one museums around the world including the most recent acquisition of her bronze *Isaiah* by the Papal Chapel in Roudine, City of Peace, Arezzo, Italy. "My dialogues with stone and steel fire my creative juices," she writes. "And playing with pieces of clay can carry me from an abstract line into a direction that takes hold until images emerge and take form." Here the creative force takes over. She describes

this as "the moment when you become a vehicle for the infinite." When this happens, when the creative force takes hold, there is no stopping it despite the odds and obstacles. For Essie Pinsker, "Sculpting is an obsessive, arduous process where exhilaration and doubt are ever present. But I continue working, ever watchful for the creative spark that will push the piece forward and look for the moment when I can still the human need for resolution and let intuition propel me." (Visit Essie's web site http://www.essiepinsker.com where it states: "Pinsker's intensely personal style of sculpture attempts to reconcile the human with the divine in a panorama of metaphors and characters drawn from the Bible and mythology, as well as from the artist's own emotional landscapes.")

Try looking at a mirror. See your reflection. Notice that place between your eyes. No matter how you turn or twist, you cannot get away from being the central image. You are the focus of your world. As a writing exercise, find a quiet place in the country. Sit down and listen. Feel your connection to what is around you. Being human is but one form of nature. Feel, see, smell, hear the bond you have with your surroundings. The universal, natural forces are latent withn you.

Deerhaven Lake © 2005 Ed Knepley
http://www.pbase.com/ed_k

11

Symbols, Math, and Nature

*Turn therefore from the common themes to those which
your everyday life affords; depict your sorrows and desires,
your passing thoughts and belief in some kind of beauty—
depict all that with heartfelt, quiet, humble sincerity and
use to express yourself the things that surround you.*

Rainer Maria *Rilke's Letters to a Young Poet*

"Nature itself is a symbol. It is a symbol in the whole and in every part." (Emerson) The universe for Emerson was but the externalization of the soul. Thus, if we follow his reasoning, the "use of symbols has certain power of emancipation and exhilaration for all men."

The rounded world is fair to see,
Nine time folded in mystery:
Though baffled seers cannot impart
The secret of its laboring heart,
Throb thine with Nature's throbbing breast,
And all is clear from east to west,
Spirit that lurks each form within
Beckons to spirit of its kin;
Self-kindled every atom glows,
And hints the future which it owes.

Ralph Waldo Emerson, *The Essay-Nature* 1844

Let us go back in time, back to the beginning, back to the history of man as we know it. Civilization began with man observing nature and making it work for his needs, his comforts and nourishment.

The plants, rocks, fire and water all are alive. They watch us and see our needs. They see when we have nothing to protect us, and it is then that they reveal themselves and speak to us.

Apache Indian tale

In the beginning, man lived much in the manner of animals, but, unlike animals, man had the ability to analyze and compare, and a memory to retain what he observed. While animals relied upon instinct, man relied on calculations. The biggest change probably occurred during what is known as the Neolithic period when man changed from hunter to farmer, around 10,000 BC. Land had to be measured for planting and fencing. Simple geometric shapes defined the areas; the shortest distance between two points was a straight line (this is pre-Boolean; it is earth measurement). With the construction of dwellings came the concepts of parallel, vertical and perpendicular lines. On a plateau in the Jordan River Valley lies the ancient town of Jericho (9000–4000 BC). This town was built during the proto-Neolithic period, the age of the beginning of food production and domestication of animals. Around 8000 BC, Jericho underwent a spectacular change. Houses were built of mud brick on round or oval foundations to form a new town. Eventually, walls were constructed for protection. By 7500 BC, the town had a population of approximately 200. Surrounded by a ditch and a wall five feet thick, the town was well fortified. Into the wall, the residents built a 30-foot high tower, 30 feet in diameter. Considering the primitive tools, which have been excavated from that period, the construction of that tower was a remarkable achievement. Some understanding of mathematics was certainly a prerequisite. A book by Seton Lloyd, Hans Wolfgang Muller,

and Roland Martin, (*Ancient Architecture: Mesopotamia, Egypt, Crete, Greece*, 1974) gives many graphic explanations of early architecture. Certainly, the pyramids of Egypt depict a vast wealth of mathematical genius and other such mysteries as we may never understand. More on this further on when we discuss the significance of the triangle.

Webster defines mathematics as "the group of sciences (including arithmetic, geometry, algebra, calculus, etc.) dealing with quantities, magnitudes, and forms, and their relationships, attributes, etc, by the use of numbers and symbols." The ancient Greeks gave us geometry which dealt with simple forms: spheres, cones, and cubes. But, according to Hermann Herkel in his work on the history of mathematics, as early as the fifth century BC, Greek geometry refused to rely on direct visual context. Rather, every proof relied upon a preceding axiom. In Greek geometry, the so-called discoveries were made using simplistic or symmetrical shapes. The Pythagorean Theorem was first illustrated using an isosceles triangle. But which comes first, the chicken or the egg? Does geometry exist in the real world? Can it be observed? Or is mathematics a figment of man's mind, created to fit and fulfill his intellectual curiosity?

Let us return to the Greek root word, *mathema*. 'What is learned' does not occur in a void. In fact, even the tenants of the theory of entropy, which has come to mean the universe is ultimately chaotic, are becoming aware of the actual uniformity of even the smallest particle or atom as observed under a special microscope. Perfection may not be readily observable, but as relates to shapes, it is observable using high technology. The microscope and the computer are recording minuscule ideal forms. Therefore, what began as observed data was refined and made uniform and, therefore, 'ideal', in order to satisfy theorems and formulas.

As we stated earlier, the word 'mathematics' comes from the Greek word, 'mathēsis' which translates as the way or method of learning or how

to learn, and pertains to any science. The study of nature in ancient Greece was considered pure science. Epistēmē is the Greek word for the way of studying which we translate as epistemology, the study of the origin, nature, methods and limits of knowledge. One way of studying and knowing was via mathematics using shapes and forms in two and three dimensions as depicted in spheres, cones, and cubes. The term 'geōmetria', the measurement of land, comes from 'gē' which means the earth, and metria, which is translated as measurement. According to Hermann Herkel in his book on the history of mathematics, as early as the fifth century BC, Greek geometry refused to rely on direct visual context. Since we know that the Universe and nature are fluid and forever changing, it is difficult to calculate visually. Accordingly, every proof relied upon a preceding axiom.

This is how Werner Heisenberg (1901–1976) analyzed our approach to our view of nature. "Natural science does not simply describe and explain nature; it is part of the interplay between nature and ourselves; it describes nature as exposed to our method of questioning."

What this all leads to is this: What began as observed data, was then refined and made uniform (and, therefore, in a sense, idealized) in order to satisfy theorems and formulas, and now has come full circle, returning to the status of the observed.

Geometry is, as we have said, an area of mathematics which analyzes the properties of lines, angles, surfaces, and solids. Certain forms and shapes appeal to the mind. The ancient Greeks invested geometry and geometrically-derived ratios with 'meaning.' Take the 'golden rectangle' for example. It was used in Greek architecture (the Acropolis); later it was endorsed by Kepler (the 'divine proportion') in the Middle Ages, and now it continues in many modern experiments. The golden rectangle awakens something familiar and pleasurable in the human

psyche. Mathematics is an abstraction whose proofs rely upon logic; but in another sense, mathematics defies logic in its emotional appeal.

Kepler did not want to be bound by the simple logic of mathematics. "I beseech thee, my friends, do not sentence me to the treadmill of mathematical computations, and leave me no time for philosophical speculations which are my only delight," said the great mathematician. Enthusiasm and imagination enhansed Kepler's rational, pragmatic mathematical thinking. Creativity and speculation is what led Kepler to the discovery of his 'Three Laws' of planetary motion. Kepler's novelty was the fusion of physics and geometry. Considering his time in history, 1571–1630, this was indeed a creative act.

But in ancient Greece, from about 1100 to 700 BC, man's knowledge about nature came not only from observation but from his desire to comprehend its innate sythesis of opposites, of harmony. Again, these Greeks placed 'meaning' to various geometric shapes as in the Golden Rectangle example above. For instance, the cube represented kingship and 'earthly foundations.' The Golden Section represented wisdom and philosophy. The shrines to the gods were built using the Golden Section. The edifices for kings were more cubic in design.

In Samos, Ionia (Greece) about 580 BC, Pythagoras was born. Although clothed in mystery, this Greek philosopher, known for a theorem he inherited rather than developed (the theorem was probably deduced by the Babylonians 1000 years before, but Pythagoras was most likely the first person to prove it) believed that "all relations could be reduced to number relations," a generalization gathered from observations of music, mathematics, and astronomy. According to Aristotle's *Metaphysics,* the Pythagoreans "supposed the elements of numbers to be the elements of all things, and the whole heaven to be a musical scale and a number."

Pythagoras founded a philosophical and religious school in Croton. The most important discovery made by this school was "the fact that the diagonal of a square is not a rational multuple of its side." The existence of irrational numbers challenged all formerly held beliefs. Philosophically, the implications extended further still.

Plato (Circa 428–347 B.C.), on the other hand, had faith in the ultimate rationality of nature, believed there was one perfect version of everything, and that the key to understanding nature was to be found in the ideal, perfect world of mathematics. Plato's writing, though philosophic, is very readable and stands on its own as a great literary work although it may be a compilation of philosophic writings from many authors. In the *Republic,* where he describes a perfect society, he wrote: "And the qualities of number appear to lead to the apprehension of truth…. Beyond anything." And further: "… geometry is the knowledge of the eternally existent." He went as far to put the following quote above the door of the Academy: "Let no one ignorant of geometry enter here."

The most notable student of Platonic thought was Aristotle. Going a step beyond the current philosophic ideas of his time, Aristotle stated that it was only through keen observation and experience that the secrets, the mathematical structure of nature, could be understood and/or discovered.

As the centuries went by, scientific research enhansed art with its new discoveries. During the Renaissance, artists and scientists interacted. Anatomical studies and mathematical perspective made possible the accurate and realistic portrayal of people, animals, and physical space. Mathematics also allowed the artist to realistically portray a three-dimensional subject on a two-dimensional canvas. "The first object of the painter," said Leonardo da Vinci (1452–1519), "is to make a flat plane appear as a body in relief and projecting from that plane." The challenge to accurately represent an object or image was approached in the spirit of

rational, methodical inquiry. Artists went beyond just observing nature and natural forces and began to instill ideal and intangible qualities to their art. Again, mathematics was implemented toward this ideal.

Mathematics is a tool. It creates harmony, from music to paintings to architecture. It is this aspect of mathematics which led Karl Theodor Wilhelm Weierstrass (1815–1897) to state: *"No mathematician can be a complete mathematician unless he is something of a poet."*

Similarly, Poincaré (French mathematician, theoretical physicist, engineer, philosopher of science, 1854–1912) wrote:

> *"The mathematician does not study pure mathematics because it is useful; he studies it because he delights in it and he delights in it because it is beautiful."*

Another mathematian/researcher contends that the beauty in mathematics lies in its stirring up memories buried in the subconscious, awakening these feelings to the conscious level of the mind. Examples of this are: 1) the alternation of tension and relief; 2) surprise at the unexpected; 3) the perception of unsuspected relationships; 4) brevity; 5) unity in variety; 6) a sensuous pleasure; and 7) a sense of wonder, even of awe. All seven of these examples could be equally applied to the arts and creative writing in particular.

Whatever our approach, it is universally agreed that nature affects us: our bodies (physically), our minds, (mentally), and our souls, (spiritually). We draw from nature and in return, we become her eyes, ears, and her speech. The trees don't know the formula, but, as in the case of the Dogwood, every spring each flower is a perfect configuration of quadrants, four matching pedals around a center puff made up of tiny yellow balls. I imagine if we counted the balls, they too would have the identical number. Balls or circles and triangles, quadrants, these

reflect some of the some of the speech aspect (translation: symbols), used to describe nature. "The use of symbols has a certain power of emancipation and exhilaration for all men." (Emerson)

Let us look at the most common symbols.

The circle ● is the universal symbol of wholeness as unity. According to St. Augustine, the nature of God can be described as a circle whose center is everywhere and whose circumference is nowhere. Representing resistance and intensity, the circle encourages control, erudition, enlightenment, and the acceptance of endings. "Our life is an apprenticeship to the truth, that around every circle another can be drawn; that there is no end in nature, but every end is a beginning; that there is always another dawn risen on mid-noon, and under every deep a lower deep opens." (Emerson, *Circles*)

The cross ✚ is a universal symbol of relationships, of integration with each arm length equidistant from the center. This form symbolizes the need for collaboration, shared work and activities. In the negative, it can also mean fear of abandonment or a search for connections with others.

The Christian symbol with the cross bar at the top quarter represents the death of Christ. The death of Christ represents compassion, passage, and eternal life. To the Buddhist, that same symbol might represent the 'I' being crossed out. The Buddhist word for this is *anatta*, meaning 'non-self' or selflessness. My poem reflects the meaning and the source of *anatta*:

ANATTA, A QUEST
Sound and light,
Flashes from the dark
Penetrating the woods and streams within my skin
As I lose the walls of my body and succumb to the rays of light.

The rhythm of chords, shaking, quickening my nerves.
To lose oneself – myself –
To feel, to become,
To emerge, to blend, to grow,
To love and be,
Without form, without parameters,
Self-less.

To better explain this concept, I defer to Father Joseph Roccasalvo. Fr. Roccasalvo is a Roman Catholic Priest who, until 1984, taught at universities and colleges in graduate and undergraduate programs. One course, 'Freud and Buddha,' was conducted at Manhattanville College where I was privileged to be one of his students. Father Roccasalvo followed his graduate degrees in Philosophy, English Literature, and Theology with a Harvard Ph.D. in Comparative Religion and a specialty in Buddhism. He has lived and taught in Boston, Bangkok, Chicago, and, for ten years, in New York City. He was also visiting professor of Buddhism in Lugano, Switzerland. However, since the mid 1980s, Father Roccasalvo has devoted his time to his two alternative loves: priesthood and prose. His writing has been prolific including seven novels, collections of short stories, a Memoir, plus a play, a one-man show in which he himself performs. Visit: http://www.josephroccasalvo. com. "I have been interested in comparative religious doctrinal issues, especially Buddhism, insofar as they contribute to the search for a contemporary spirituality. I have explored the contrast and affinity between Judeo-Christian and Buddhist doctrines, and between Buddhism and Depth Psychology," writes Father Roccasalvo. Apropos the symbol of the cross, he wrote:

I had experienced transience at an early infantile stage, and so
learned the lesson of Buddhist impermanence before I could

articulate it in Buddhist symbols; these, once discovered and internalized, made me feel I had come home. In short, I learned to be Buddhist by natural affinity, and a Catholic Christian later, a priest – by conversion. The dialogue of Christ with Buddha is my internal conversation that never ceases.

The Christian symbol of the cross whereon Jesus was 'emptied' of all self was viewed by one Buddhist monk as the equivalent of the Buddhist doctrine of non-self, anatta, where all self identity is transcended; hence, the remark, 'Ah yes, the Cross, it is your 'I' crossed out.' One is at zero, the point of pure receptivity, for here the totality of being is embraced. In brief, 'you' are the works.

It's a religious version of the literary quest for the concrete universal in myth and symbol.

For another perspective on this subject, let's read the words of Joseph Campbell. On the one hand, he was immersed in the rituals, symbols, and rich traditions of his Irish Catholic heritage; on the other, he was obsessed with 'primal' people's direct experience of what he came to describe as "the continuously created dynamic display of an absolutely transcendent, yet universally immanent, *mysterium tremendum et fascinans*, which is the ground at once of the whole spectacle and of oneself." (*Historical Atlas*, I.1). Mr. Campbell traveled all over the world comparing sagas, stories, and myths. His conclusion from these observations was that we are essentially all one. In 1984, I was privileged to attend one of his lectures at UCLA. Standing quite inconspicuous to the side of the stage, behind a podium, Mr. Campbell was dwarfed by a giant screen onto which he projected slides. Sometimes he enhanced his talk with music. The story was and is always the same. It is the hero's journey. The quest.

The privilege of a lifetime is being who you are. The goal of the
hero trip … is to find those levels of the psyche that open, open,
open, and finally open to the mystery of your Self being Buddha
consciousness or the Christ. That's the journey.

According to the Joseph Cambell web site, "In his later years, Joe was fond of recalling how Schopenhauer, in his essay *On the Apparent Intention in the Fate of the Individual,* wrote of the curious feeling one can have, of there being an author somewhere writing the novel of our lives, in such a way that through events that seem to us to be chance happenings there is actually a plot unfolding of which we have no knowledge." Written by members of the Joseph Campbell Foundation, they conclude, "Looking back over Joe's life, one cannot help but feel that it proves the truth of Schopenhauer's observation."

The symbol for the stability of life itself is the square ■. The square encourages security, and groundedness. On the reverse side, the square discourages conflict, nervousness, venture taking, and individuality.

To me, however, the most powerful symbol of all is the triangle ▲ a universal sign of the attainment of goals, envisioning new possibilities. The triangle can also represent heat, activity, and action.

The world is three-dimensional. The third dimension is depth. Since sometime before 4500 BC, the number three has been recognized as symbolizing the spiritual aspect of life. It has also represented the ultimate spiritual being or God. "God in his state of resting within Himself is 1 in 3 and 3 in 1." (Elizabeth Haich, *Initiation*) The New Testament of the Bible depicts God as the Trinity. The Cherokee Indians symbolize the spiritual aspect of reality with the number three, a universal force which has intelligence. In geometry, the idea of 3 in 1 and 1 in 3 is represented

by the triangle. The triangle represents perfect harmony, especially the equilateral triangle, each side being the same length.

In ancient Egypt, pyramids rose up, and these three-dimensional triangular forms are shrouded in mystery to this day. It has been said the shape, as well as the angle of the surface of the pyramid in relation to the forces of energy circumventing the globe, cause energy to be harnessed within the pyramid. Dead carcasses have been found inside these structures but with no odor. Razor blades have been sharpened. Mummies have been preserved within a pyramid. Aesthetically, the pyramids are beautiful as their four triangular sides reach from a square base to a point reflecting the angles of the sun: the light at dawn, the brilliance at noon and the golden sunset. Yet how they could be constructed, each piece of stone weighing close to 300 tons, is a mystery yet to be revealed. The Great Pyramid was constructed circa 2500 B.C. How could workers using the primitive tools and methods of that era accomplish such a feat?

Consider the shape of a triangle ▲ symbolically. It has three sides and three points. At point number one, take the representation as self: you, the artist/writer. The second point represents what is 'out there': what you see. At point three, the most important point of all, the representation is the result of combining the first two. Your relationship with reality (what you see) becomes your art/writing/painting.

The Cherokee Indians have a symbol with a star in the middle. The star has seven points and ends with the number 9! How can that be? They start with the number 3. Why? Number one is myself. I know who I am. Number two is what is out there. I know that is real. Number three is the first unknown; it is the source of one and two: the Creator/God. "Apart from their belief system, perhaps the most valuable contribution of Native American spirituality is the insistence that the sacred power of the Universe must be experienced first hand." (From a sermon by Ed Piper, Minister, Universal Unitarian Church, Charlottesville, Virginia, 1995.)

> *To put everything in balance, that is good; but to put everything in harmony, that's better.*
>
> Victor Hugo

Beauty is harmony. Mathematics is the tool to create harmony, from music to paintings to architecture to writing. But, ultimately, beauty/harmony/happiness comes from the heart.

> *Whoever rides the wind*
> *and flows upon the tides*
> *is one who knows*
> *the careful mind considers*
> *but the heart decides."*
>
> Elinor Roberts Hartt

12

The Metaphor

*[M]etaphor consists in giving the thing a name that be-
longs to something else; the transference being either from
genus to species, or from species to genus, or from species to
species, or on grounds of analogy.*

<div align="right">Aristotle, Poetics</div>

*My life in art is about an endless search for meaning. It's
about a deep spiritual and metaphysical search to reconcile
the human with the divine. The conflict is always between
what is real and what is unreal. I never shy away from the
absolute but seek proof in symbols and metaphors. My
dialogues with stones and steel fire my creative juices. And
playing with pieces of clay can carry me from an abstract
line into a direction that takes hold until images emerge
and take form. This is the moment of truth, the ultimate in
letting the creative force take over. The moment when you
become a vehicle for the infinite.*

<div align="right">Essie Pinsker</div>

The word, metaphor, comes from the Greek; *meta* means 'over'
and *phorein* means 'bear.' Translated, it means to bear, carry, or
take over; to transport. Grammatically speaking, a metaphor is a figure
of speech in which a word or phrase that ordinarily designates one
thing is used to designate another thus making an implicit comparison.
Everyday language is widely metaphoric. To write metaphorically is to

see likenesses. Kenneth Burke stated (in *Four Master Tropes published in 1945*), "*Metaphor is a device for seeing something in terms of something else.*" Burke's research and concern was not with mere usage but with the role metaphor (and irony, metonymy, and synecdoche) played in the discovery and description of "the truth." Some examples: 'a sea of troubles,' 'screaming headlines,' 'an empty dream.' Metaphor is pervasive in our daily lives, so much so that metaphor can be said be powerful enough to provoke thought and action. For example, take the word war and see it applied in these conceptions of an argument. Your claims are *indefensible*. He *attacked* every weak point in my argument. Her criticisms are right *on target*. I *demolished* his argument. Try that *strategy* and I will *wipe you out*. She *shot down* all my arguments.

There is a mothering force to language and to the use of metaphors in particular. When you use language, you will find that it uses you. In fact, most often, it takes over and you sit back and learn from your own words. The vision of the thing perceived can be so much stronger when re-invented or re-interpeded by your memory of the thing or of the occurance. An analogy could be found in the story of Picasso and Gertrude Stein. When he was still quite young (in his late twenties), Picasso attempted to paint a portrait of Gertrude Stein. She sat for hours posing day after day. When he finally gave up, she pouted, and who can blame her? But, in fact, he wasn't really finished. Picasso left for a short time and retruned to his native Spain for a visit. When he came back, he had an inspiration. Returning to his studio in Paris, he put up a canvas, arranged his oils and brushes and, from memory, painted Miss Stein's portrait. When he showed it to her, she was surprised. As her companion, Alice B. Tohlas writes, "I murmured to Picasso that I liked the portrait of Gertrude Stein." But she was hesitant because it didn't really look like her friend. His reply? "Yes, everybody says that she does not look like it but that does not make any difference. She will." And she did, but many

years later. In her book about Picasso which was first published in 1938, Miss Stein wrote, "In the nineteenth century painters discovered the need of always having a model in front of them; in the twentieth century, they discovered that they must never look at a model."

Many metaphors are familiar throughout the history of thought (and "all history, properly understood, is the history of thought." R. G. Collingwood): the sun as wisdom; dark caves and ocean depths as death, evil and ignorance; water as life; the waning and waxing of the moon as death and rebirth. Consider bridges as well. All bridges speak the language of metaphor. Bridges are the stuff of legends and folktales throughout history. However, what is far more exciting about the metaphor is its unique character and its origin, both of which come from you, the writer's mind. As a figure of speech, a metaphor 'becomes' the 'other.' It is much more powerful than a simile. (Example of a simile: She donned a cloak of mourning like wrapping herself within a dark cloud. Metaphor examples: The wings of experience drove her forward). Connecting two things or ideas in a metaphor adds a new dimension, another layer of understanding. Personification is a particular type of metaphor. For example, arms of a chair or legs of a table or 'the water cried out throatily to the landscape, I love you!'

Metaphorical knowledge transcends rational knowledge. Metaphor invites active participation. It is, therefore, not static but dynamic. In the Bible, Jonah is swallowed by a whale. "Now the Lord had prepared a great fish, and it swallowed up Jonah. And Jonah was in the belly of the fish three days and three nights." *(Jonah 1:17)* Metaphorically, a *fish* or a *whale* means trouble, difficulty and dilemma. I have been told the early word in Aramaic for 'whale' was 'dilemma.' (Consider how we say, when someone is lost in a city, "He has been swallowed by the city" and when someone is in a dilemma, we say "He is at sea," or "in the sea.")

Metaphysically, *Jonah* means that prophetic state of mind which fixes man in bondage by his belief in the law of cause and effect. (Refer to Charles Fillmore, *Metaphysical Bible Dictionary*). Another biblical name, 'Abraham', translates as 'I am all'. The Bible is rich in metaphor.

Life is a mystery, and transcends meaning and definition. The "rapture" (to use Campbell's word) comes when we spontaneously discover or experience an 'ah ha!' moment. "The world of life speaks within us when we let the active imagination function." The metaphor epitomizes this relationship between life (what we see and experience) and imagination. We must embrace life while we have the time and energy.

> And as you read
> *The sea is turning its dark pages*
> *Turning*
> *Its dark pages.*
>
> Denise Levertov, 1923–1997, poet

Carl Gustav Jung translated John 3: 3–7 as: "And Jesus said to Nicodemus: Do not think carnally, or you will be flesh, but think symbolically, and then you will be spirit." The key is to allow your thoughts to become realities on their own. Combine your experiences and your education with what you perceive today/now. Out of this mixture may evolve something new, a possible metaphor to transport you up to the level of the spirit.

Analogy, the basis of metaphor, relates the temporal to the transcendent. Thus metaphors can be rich far beyond their rationale. To use one of Joseph Campbell's example again, you describe Jack as running quickly with the following sentence: 'Jack is a deer.' This metaphorical knowledge about Jack transcends rational knowledge. This is Jack's mythic reality, a psychologically compelling symbol of the person Jack.

There can be an amusing side to metaphors and similes. One of my favorite writers is Tom Robbins. I invite you to enjoy some lines from '*skinny legs and all*': First the simile:

> *Like a neon fox tongue lapping up the powdered bones of space chickens, the rising sun licked away the light snow that had fallen during the night.*

Then the metaphor:

> *It was a bright, defrosted, pussy-willow day at the onset of spring, and the newlyweds were driving cross-country in a large roast turkey.*

I won't explain that one; I just hope it entices you to read the book. At the very least, the exposure might enhance your own writing. Coming up with metaphors can be fun, but do remember, it can also be enlightening. For Goethe wrote: *"Everything phenomenal is a metaphor."*

Now let your imagination take you for a ride.

13

Myth

[M]yth is the secret opening through which the inexhaust-
ible energies of the cosmos pour into human cultural mani-
festation.

<div align="right">Joseph Campbell</div>

The habit of telling stories is one of the most primitive traits of the human race. The earliest myths were simply a way of explaining death, birth, the sun, thunder, and the world as it was observed. In these early myths, natural forces were not personified. The storm or ocean or disease was a person, a divinity. In Greek, *mythos* means 'fable,' 'talk,' 'speech.' By the time the myth came to the more evolved civilization of Greece, man had come to recognize his separateness. Myth became religion. As the eminent scholar of comparative religions, Mircea Eliade, states in *Myths, Rites, Symbols*, in sacred societies, myths gave "meaning and value to life." In fact, the narrative poet, Homer, was the first to admit to feelings and emotions as belonging to him or his characters and not emanating from the gods (although like Socrates and Buddha, he may represent many poets since nothing has been handed down that was written by him).

For thinkers like Eliade and Carl Jung and Joseph Campbell, myths are far more than fiction; they are real and necessary and very significant to the human psyche and the human race. Ultimate reality is irrational, beyond reason, and is justified by myth, according to Friedrich Nietzsche, a German philosopher who lived from 1844 to 1900. He wrote, "[M]yth can

itself only be defined in terms of the constant elimination of definitions."
Myth both reveals and conceals, an arbitrary and ironic sort of thing. It
resides in an intermediary state between the conscious/real/fact and the
subconscious/dream/potential. It is beyond the confines of time and
space. It is cyclical as opposed to linear. It is through myths that the world
is justified as an aesthetic phenomenon. (Remember that *aisthētēs* is the
Greek word meaning 'one who perceives.') Soren Kierkegaard (1813–
1855), Danish philosopher and writer of religious themes, stated it this
way: "The mythical is … the enthusiasm of the imagination in the service
of speculation…. We have need of myth for the enchantment of the soul."
The subject of myth is at once true and not true. The objective of myth is to
explain the unknown.

Myth also satisfies the emotions (and the emotions must be satisfied
if the intellect is to be convinced!). "To transform the external world
into the inner domain of the psyche is the role of myth." (Karl Reinhard)
Birth, death, love, guilt, quests, rebirth – these are all the essence of
myth. Myths are the archetypes, the emotional patterning, whose
unconscious charge can stir and disturb us.

Facts and reason cannot ultimately define what is real. Myths were
created to explain what could not be rationally defined or understood.
The myth is the story of that common thread that ties us together as
humanity and which binds us to the world in which we live. It is real in
that it relates to the world; it is unreal in that it requires the imagination
to comprehend.

In his preface to 'A Wonder Book for Boys and Girls,' published in
1851, Nathanial Hawthorne said of the Greek Myths (which he rewrote
in this book): "They seem never to have been made; and certainly, so
long as man exists, they can never perish; but by their indestructibility

itself, they are legitimate subjects for every age to clothe with its own garniture of manners and sentiment and to imbue with its own morality."

Mythology allows the mind to participate in an abstract field, a field full of intense meaning. History and psychology come into play in mythology (although Nietzsche felt Greek myths died when they took on historical significance). What is valuable, however, is the process, not the result. The creative journey, not the created. Myth encompasses all this. The myth is a story which is dreamlike, being poetic, philosophical, historical and even religious. Read Joseph Conrad's *Heart of Darkness.* The novel is multi-layered, philosophical, abstract, but also entertaining, interesting, and stimulating. While following more or less a story line, the novel is more concerned with asking questions than in providing answers. On one level, it is sheer myth.

> *It was as though a veil had been rent. I saw on that Ivory face the*
> *expression of somber pride, of ruthless power, of craven terror – of*
> *an intense and hopeless despair. Did he live his life again in every*
> *detail of desire, temptation, and surrender during that supreme*
> *moment of complete knowledge?*

It was at this moment in the novel that Kurtz cried, "The horror! The horror!" Then he died. In essence, the story symbolizes Conrad's concern for man's place in the "tremendousness of the universe" as his protagonist, Mr. Kurtz, takes a "night journey" into the savage heart of Africa only to discover the darkness of his own soul.

The myth is, by its own definition, true and not-true; "myth can itself only be defined in terms of the constant elimination of definition." (Neitschze) The object of myth is the unknown. Myth is irrational, beyond time and space, and ultimate reality is also irrational. It is cyclical as opposed to linear.

Myth harkens up the enthusiasm of the human spirit. And our enthusiasm may come from searching the mysterious. And what better source than the myth. For myth is mystery, such as who tamed Pegasus? As Albert Einstein said: "The most beautiful experience we can have is the mysterious. It is the fundamental emotion which stands at the cradle of true art and true science. Whoever does not know it and can no longer wonder, no longer marvel, is as good as dead, and his eyes are dimmed."

Carl Jung (1875–1961) who was blessed with a long life, was also cursed to live to see what the human race was doing to itself. He viewed this period as "an age filled with apocalyptic images of universal destruction." The 'iron curtain,' the hydrogen bomb, state absolutism, and other threats concerned him. He was so concerned that in 1957 he wrote: "Is [man] capable of resisting the temptation to use his power for the purpose of staging a world conflagration … ? Does he know he is on the point of losing the life-preserving myth of the inner man which Christianity has treasured up for him?" It is the individual acting on his own initiative, he affirms, who is the "makeweight that tips the scales." He further affirmed he was "neither spurred on by excessive optimism nor in love with high ideals, but merely concerned with the fate of the individual human being – that infinitesimal unit on whom a world depends, and in whom, if we read the meaning of the Christian message aright, even God seeks his goals." To counter the possibility of destruction, therefore, Jung affirms that man can overcome malice and resist the dominance of evil, by affirming his individuality, his "self-knowledge." To some, these words would come across as slander. But to others, it would be right and appropriate when Jung asks us, the people of today, to understand the symbolism of what he calls "the Christian mythology." Be assured, he is by no means demeaning the Christian faith. "The objection that understanding [Christianity] symbolically puts an end to the Christian's hope of immortality is invalid, because long before the coming of

Christianity, mankind believed in a life after death …." He continues, "The danger that a mythology understood too liberally, and as taught by the Church, will suddenly be repudiated lock, stock and barrel is today greater than ever." (Remember, this was written in 1957!) "Is it not time," he asks, "that the Christian mythology, instead of being wiped out, was understood symbolically for once?" (For more information on this topic read Jung's *The Undiscovered Self [Past and Future]*; in particular, the Chapter, The Plight of the Individual in Modern Society.)

All the parables in the New Testament are built around metaphors. This is not a travesty. It is a recognition of what can be learned, for the text is rich with truths. For example, the books contained within the New Testament were not written right after Jesus' death. The stories pertaining to Jesus' life and death were passed down for years verbally and when stories are passed down this way, they become an oral tradition and can be altered as memories fade. These were the days before pen and paper (although there are writings on papyrus). The theory is that it was at least fifty years after the death of Jesus before any of his life and his life's work was collected and documented in writing. According to Rita Louise and Wayne Laliberte in their book, *The E.T. Chronicles, What Myths and Legends Tell Us About Human Origins:*

> *Books of Jesus's life and teachings that fall outside the current Bible, called the Apocrypha, are not accepted in much the same way. Manuscripts such as the ones found in the Egyptian town of Nag Hammadi are believed to have been written sometime during the fourth century CE. These books include the Gospel of Thomas, the Gospel of Mary, and the Secret Book of John. Were the concepts depicted in these texts a part of the original teachings of Jesus' ministry?*

Passing information down by word of mouth was the culture of our ancestors. This information became myths and was the tradition long

before the creation of the printing press. Our primitive ancestors probably anthropomorphized word pictures to express feelings; adjectives came later. Alfred Korzybski makes quite a case for this rudimentary language pattern in his chapter on abstraction in *Science and Sanity*. Observation of the world about him was the key to our ancestor's developing a language. But, in the development of western civilization, it was not until the time of Homer that man acknowledged passions or feelings as his own. Up until then, every emotion was attributed to "the gods." Obviously between our primitive ancestors and Homer there was an evolution of language which incorporated abstractions including adjectives and adverbs. But in ancient Greek drama, emotions were voiced by a Chorus who stood between the audience and the stage (almost as a barrier to protect the tender ears of the audience) and on the stage, emotional dilemmas were depicted by actors and actresses dressed as gods and goddesses. To trace the concept of abstraction further would necessitate researching the origin and evolution of analogies and metaphors which preceded the Greeks.

In 1974, my father wrote the following letter to me which I feel is worth quoting as a contribution to the concept of myths and the Bible.

> *I, too, believe in God – very deeply and sincerely. Further, I believe that He encompasses the entire universe and not just our very small, insignificant world for the benefit of our intelligent (?) beings called mankind …. .*
>
> *[W]hy have we been so fearful of exploring the past completely, openly, scientifically and without fear – particularly without fear of upsetting some of our convenient and complacent ideas that we have been taught to accept without question, and also without proof of their being either correct or incorrect?*

Let's explores a few avenues. What about the Piri Reis map which clearly shower the contours of North and South America and Antarctica in correct relation to Europe and Africa to such an extent that when placed side by side with one of our moon space shots are virtually identical, even to the distortion caused by the fact that our earth is round?

The Bible tells us many things. The Flood, for example, where various events can be traced back to Hindu scriptures written many centuries' earlier, the antiquity of the Babylonians who claimed that the then God Cronus foretold the Flood to Sisithrus who built an Ark, sent out three birds and landed on the mountain Armenial; the-Gilgamesh Epic written in Akkadian in which Ea (Oannes) advised Utnapishtim to build an Ark and load it with every kind of living creature; the Ramayana; the Sumerians, Egyptians, ancient South Americans, even Eskimos, you name it, all have floods. Which came first and who is copying from whom?

Was Homer's Odyssey inspired by the Gilgamesh Epic written in Akkadian, mentioned above. Gilgamesh, part divine and part-human, named in the Sumerian King List as the fifth King of the first Dynasty of Erech after the Flood, To me the "part-divine and part-human" means the possibility of an offspring from the mating of an earthling with intelligence from outer space as the primitive mind could only think of spacemen or women as being divine, regardless of whether the intelligence from outer space, if it actually happened, intended it that way or not.

As for Moses, I do not recall anything about his being one of those "cross between the races." However, just how many parallels' are there? Zoroaster's mountain was bathed in fire when he heard the

*Revelation of God and filled with mimic understanding descended
to teach the Persians' about Ahura-Mazda and his struggle
with Augra Manyou. Good against Evil. And other mountain
enlightenments such as: Hammurabi, Minos and Mahomet.
Personally, I do not know whether Moses, or anyone else, was the
offspring of an earthling and an intelligence from outer space and
do not find it a challenge to my belief in God as He encompasses the
entire universe. Most countries have at least one sacred mountain
associated with the manifestation of the Gods. The Hebrew 'El
Shaddai' (God Almighty) is reminiscent of the Syrian God, Addu,
(Hadad) mentioned in the Armani Tablets; Ugaritic texts refer
to Yawe, the son of El. The Sumerians equated Him with Enlil;
the Babylonians with Marduk. The Covenant between God and
Abraham was paralleled by similar divine protection between
Athena and Odysseus; Aphrodite and Anchises; Ishtar and
Hattusili and most ancient countries plus too many modern lands
believe themselves to be God's "Chosen People." Strange also is the
fact that no Egyptian inscription ever mentions Joseph, Moses or the
long captivity. So how does one date, precisely, the events of Exodus?*

*One more thing. We have been referring to the Old Testament,
other Religions, and Legends. What about the New Testament,
which was written over a hundred years after Jesus Christ was
crucified and until then was by word of mouth? Try telling some
of your friends a story about anything. Let it go around your circle
for a few days and then get someone to tell you the story that you
started. You may have a bit of trouble recognizing the changes that
have taken place.*

*As for the book about the Spaceships of Ezekiel, that was written
by a NASA engineer who started out with the attitude that all*

was silly, science fiction. Then, to his utter amazement, he found
that Ezekiel's descriptive powers were so exact and so accurate that
he not only was able to reproduce his conception of what the ship
looked like but, from a practical side, able to get a patent on the
wheels used on the spaceship described by Ezekiel.

One last point and then I will wind up this long-winded letter. We
are a three dimensional intelligence with a limited realization of
a fourth, generally accepted as time, which we use descriptively
but cannot move back and forth in at will. To me it seems logical
that there is four dimensional intelligence with a realization of a
fifth. And you can keep on progressing, ad infinitum, beyond that
until our finite minds become completely dizzy trying to grasp and
comprehend things that are far beyond our limitations. However,
God encompasses all and He and He alone is the One capable of
comprehending His reason for existence and, personally, I feel far
too inadequate and limited by being a mere human, to question
His judgment.

Daly Highleyman

So to return to the original theme of this chapter, myths, consider
the myth as "psychologically symbolic." Its narrative and the images "are
to be read ... not literally, but as metaphors." Joseph Campbell teaches
us to see beyond the symbols, lift the veil of illusion (*maya*). You are
your own best resource for wonder and magic.

Another linguistic aspect of creativity might be observed in
Descartes' definition of the essence of man: *"Je pense, donc je suis"* (I
think; therefore, I am), which occurs in his *Discourse on Method* (1637).
Philosophical thought expresses both the potential and the limitations
of human knowledge. It demands that we attempt to think beyond
reality. Perhaps this too is the essence of creativity?

To understand the mythical concept itself, consider myths as movement as they flow with illusion and change. Myths are always becoming. They are never static. Today, according to Nietzsche, "stripped of myth, (man) stands famished (within) his past and must dig frantically for roots" Joseph Campbell, in his book, *A Hero With A Thousand Faces,* also laments the lack of myth in the modern world. "The world formulated is aesthetic not logical. It calls for the creative process within man."

James Joyce also had his opinions about myth and man's relationship with myth. As an example, he talks about eating lunch. You or I do this every day. Somehow that lunch is digested. And do any of us know consciously how we digest that lunch? But we will be doing it; that is how the body works. So it is understood there is much more to each of us than our mental consciousness knows about or understands. "The vocabulary that relates and links our mental consciousness to the energies that inform our body and move our lives and give us sentiments of love and hate and despair is the vocabulary of myth." This idea can be applied to other non-physical ideas and actions as well. Take for example the concept of compassion. The feeling of compassion "releases you from ego orientation." Suddenly you are aware of oneness with another. It is the opposite of what Nietzsche calls the *principium individuationis* which comes as a result of the separating factors of time and space. The actual realization of identity with another, however, happens. Perhaps it only happens rarely. But when it does, it too is a true experience and, dare we say, it is an expression of that inward light, the realization of the creative muse's environment.

In his wonderful poem about the mythical figure, Paul Bunyan, W. H. Auden wrote:

> *A man is a form of life that dreams in order to act*
> *And acts in order to dream.*

Creativity does not have laws. All that is required for the writer is honesty and PRACTICE. Write, write, and write until writing becomes second nature. Live, look, listen and write. The magic is there inside every human being. You may not even know what you think about things you see and feel until you write. When writing comes by *rote*, you will look at what you *wrote* and be amazed. It is *magic*.

> *Writing is a concentrated form of thinking. I don't know what I think about certain subjects … until I sit down and try to write about them…. Words on a page, that's all it takes to help [a writer] separate himself from the forces around him, streets and people and pressures and feelings.*
>
> Don DeLillo, interview in *The Paris Review* 1995

Keep a journal. C.S. Lewis did. "I used my own pen to probe my own wound," he wrote. The journal represents in words our journey through life. The journal process frees us to slow down. Re-learn contemplation. Write about what you see, but also write about what you cannot see. The greatest satisfaction comes when we discover from our own words what we were not aware of before we began to write. "It is out of what I don't know that I begin to write." (Toni Morrison) Create or discover your own myths. Gertrude Stein pointed out that "there's no point in roots if you can't take them with you." Memory is a root into recalled stories of our past. Our personal histories are also narrative histories. Whoever said history was biography got it right. Feel your connection to the past and to the future. We are all part of the continuum.

> *A diarist is a writer who watches himself watching himself.*
>
> Edward Robb Ellis, (1911–1998)

Edward Robb Ellis was a diarist and a journalist. As a sixteen year old, in 1927, he began keeping a diary to fend off the boredom of his small Midwestern town. Seventy years later, he emerged as the most prolific known diarist in the history of American letters.

Preserve the past for the future. Write your story, share your observations. Write about everything: your first love, a bad teacher, your father's yelling at you when you fell off the bicycle he gave to you. These stories all tell about you and more. They tell about a time and place and person from the past. How else will the next generation learn about what came before? We certainly cannot rely on email! So many great ideas lost to the click of a mouse.

14

The Process

*The process of writing evokes "that emotion definite and
physical and yet nebulous to describe: the ecstasy, that
eager and joyous faith and anticipation of surprise which
the yet unmarred sheet beneath my hand held inviolate and
unfailing, waiting for release."*

William Faulkner

*T*he most valuable aspect of writing, creative writing in particular,
is the process, not the product. It is the journey, not the
destination; the creating, not the created. Nancy Willard wrote, "I
haven't a clue as to how my story will end. But that's all right. When you
set out on a journey and night covers the road, you don't conclude that
the road has vanished. And how else could you discover the stars?"

Some years ago, Phyllis Whitney told me when she begins writing,
she has no preconceived story. When she writes a mystery novel, she
said, she begins with the place. Traveling to a specific location, she gets
to know the place intimately. Then she creates some characters and
gets to know them. They develop personalities and speak to her and
to each other while she listens. Finally the plot begins. When asked if
she knew or plans ahead who did the crime or what will happen, she
laughed and said, "Of course not! I have to wait just like the rest of you
to find out!" (Paraphrased from a conversation I had with the author
in Charlottesville, Virginia in the 1990s.) And Miss Whitney is not
the only author who experienced the unexpected. In wriiting *Ahab's*

143

Wife, author Sena Jeter Naslund noted "several other characters also just materialized out of thin air, or snow, or whatever the landscape background was." Tolstoy is another example. He once wrote to his friend the critic Starkov that he (Tolstoy) was in his most creative mode when his characters surprised him and events took an unexpected turn.

But before you can 'fly off' in your writing, you need a foundation. Building a house does not begin with the roof. Toni Morrison noted there is an art to writing well which requires thrift, choosing just the right words and giving a sense of being there, plus a real yearning:

> *I was always conscious of the constructed aspect of the writing process, and that art appears natural and elegant only as a result of constant practice and awareness of its formal structures. You must practice thrift in order to achieve that luxurious quality of wastefulness....*

The structure is important. Structure is the foundation. The "thrift" is only achieved when you have allowed the words to flow and then return to find that golden phrase, that spark of insight, that flash of understanding. There is the letting go, the expression of your creative muse, that will only come as you write and write and write, much and often.

Rudyard Kipling spoke of the Daemon who "was with me in the Jungle books and both Puck books" and why he had to take great care "to walk delicately lest he should withdraw." He warns the writer, "When your Daemon is in charge, do not try to think consciously. Drift, wait and obey."

There are so many avenues to explore and every writer must find his or her own. However, one thing is true about all artists and writers: they are endlessly inventive.

Look for the extraordinary in the ordinary (take the 'order' out of 'ordinary'). Some things happen with an uncanny order called serendipity. An example of this happened to Scarlotti. A cat jumped on his piano and played notes. Scarlotti composed these very notes and created a beautiful fugue (*Cat's Fugue*).

The discovery of Penicillin was serendipitous also. Scottish biologist and pharmacologist, Sir Alexander Fleming's discovery of penicillin happened accidentally. In 1928, after returning from a month's vacation, he noticed one in his culture studies was contaminated by a fungus. This fungus seemed to inhibit the growth of his bacterial culture. Had he not gone on vacation, his observation would have been too soon to allow the fungus to grow and he would have missed the phenomena. Serendipity? In 1945, Sir Fleming shared the Novel Prize for this discovery.

Life is like that. Behind what appears as chaos or without meaning, there is, nevertheless, some kind of order. Even the mathematical interpretation of the Chaos Theory has discovered a new order in fractals. Thanks to computers, we can visualize fractals (refer to Chapter 9). A fractal geometric shape has a repetitive pattern which gives it a beautiful or pleasant aesthetic appeal. (For a better and comprehensive understanding of 'chaos' I refer you to Stephen Hawking's work).

It has been said to forget the past is to rob the future. The world is changing so rapidly as we are being transformed by globalism as well as terrorism. (As Thomas L. Friedman writes, in the twenty-first century, the world is flat. As our lines of communication connect us "which requires us to run faster in order to stay in place," we need to let our imagination act, and then to act on our imagination.) We should concentrate on what we all have in common and share our ideas in the spirit of hope for peace throughout the world.

And yes, we can learn from the past. Since history is really nothing other than some else's point of view, let your view count and help our children and grandchildren learn and grow. So, allow me to reinforce my plea: keep a journal. Some incident may seem commonplace but, upon reflection (etymology: 'bending back'), you may find it illuminating (charged with inner meaning/light). After all, "Nothing never happens." (Virginia Hearn) W. H. Auden said, "How do I know what I think until I see what I say!" You too may be amazed and the world may become a better place for it.

> *Writing is like a raft that buoys me above the waters of my life, not to keep me from having to swim, but to allow me to gather my breath, plunge deeper and delve for greater riches, then return to the raft and warming, to study and enjoy what I have found on the ocean floor.*

> Alice Helen Masek, author

15

Reading and Writing, It's Therapy!

Poem finding a path

The words stick in the teeth.

Rich and boiling, ideas copulate

with syllables, generate, bubble

inwardly upward, unhindered

until they reach the traffic jam

at the junction of brain, breath, tongue.

There in the gullet they clot, flatten,

turn hard and dull. Wrong pieces

mate and will not come unstuck.

Shards of images, the sentences

stick in the teeth

or issue in an awkward belch,

disturbing the peace

unless they find an alternate

escape route. Somehow the joints

of shoulder, elbow, wrist,

present no obstacle. Along

striated nerves and muscles, the blips

of light and color dance and flow

smoothly, string themselves

on an iambic thread, slip

their enamel down the arm

via ink, assemble, establish
themselves according to their
innate poetry, form rows
and stand up to be read.

Luci Shaw, *Polishing the Peroskey Stone*

Cadmus defended writing in rebuttal to Hercules. "I taught Greece the art of writing," he said. "You (Hercules) subdued monsters; I civilized men. It is from untamed passions, not from wild beasts, that the greatest evils arise to human society. The genuine glory, the proper distinction of the rational species, arises from the perfection of the mental powers…. Unhappy are the people who are governed by valor not directed by prudence, and not mitigated by the gentle arts." Aristotle had said, in his opinion, poetry was more philosophical than history since poetry dealt with the universal and history with the unique facts or epics, i.e. the particular. Poetry values each word. It is condensed and, as such, poetry is a great disciplinarian. Poetry also develops in the reader an appetite for metaphysics since it conveys from a personal perspective the human experience.

> *Poetry … is an incurably semantic art, and the chances for charlatanism in it are extremely low. By the third line, the reader will know what sort of thing he holds in his left hand, for poetry makes sense fast and the quality of language in it makes itself felt immediately.*
>
> Joseph Brodsky
>
> *Poetry is when an emotion has found its thought and the thought has found words.*
>
> Robert Frost

For the artist, writer or musician, the beauty of nature reflects clarity and order. Our participation in and with nature allows us to recognize that fact. The universe is truly both within and without each one of us. There is nothing new that is not old. All this, the artist observes and records.

> *Learn to get in touch with silence within yourself, and know that everything in this life has a purpose. There are no mistakes, no coincidences, all events are blessings given to us to learn from.*
>
> Elisabeth Kübler-Ross, 1926–2004

To be an artist or a writer is not a matter simply of making paintings or writing. It is a state of consciousness. It is the shape of our perception.

An essential learning tool for good writing may be obtained with no effort at all. It is called exposure. Some of the mandatory books to keep with you when you are writing include the Encyclopedia Britannica, a Roget's Thesaurus, Word Finder, the Webster's Unabridged Dictionary, Volumes I and II as well as the latest edition of *SPELL/Binder* published by the Society for the Preservation of the English Language and Literature. The computer's Google has answers, but book research is more accurate.

And reading literature published in the past adds perspective. In his closing paragraph, Barzun, author of *Simple & Direct, A Rhetoric for Writers,* states: "Reading abundantly, in good books, is indispensable. It is only in good writing that you will find how words are best used, what shades of meaning they can be made to carry, and by what devices (or lack of them) the reader is kept going smoothly or bogged down in confusion."

And read mythologies. "For mythology is the handmaiden of literature; and literature is one of the best allies of virtue and promoters of happiness. Without knowledge of mythology much of the elegant literature of our own language cannot be understood and appreciated." (*Bulfinch's Mythology,*

Introduction) The feelings both positive and negative of an individual are, when reduced to their simplest form, the same as feelings that have been expressed throughout the ages via the myth.

Read Carl Jung and his analysis of 'the collective unconscious' (what he calls 'archetypes'). It is through our emotions that we recognize ('re-know') our unity as members of the human race. Nietzsche said, "Without myth, every culture loses its healthy and creative natural process." We need to share our sameness with our fellow man. The future of the planet depends on it. So read and find the myths in literature, but also find the literature in myths.

> *The latest incarnation of Oedipus, the continued romance of*
> *Beauty and the Beast, stand this afternoon on the corner of Forty-*
> *second Street and Fifth Avenue, waiting for a traffic light to change.*
>
> Joseph Campbell

Open your eyes and you will see myths everywhere. The more you read, the more you will see and the more you see, the more you will have to write about.

Do not worry about imitation. Your own writing will, of course, respond to and reflect what you have read. However, as long as you don't plagiarize, site your resources, and retain your own 'voice', what you have read will only enhance and add to your own work.

> *There is no Frigate like a Book*
> *To take us lands away*
> *Nor any Coursers like a Page*
> *Of Prancing Poetry.*
> *This Traverse may the poorest take*

Without oppress of Toll –
How frugal is the Chariot
That bears the Human

Emily Dickinson, *Soul*

Rita Dove, poet Laureate and English professor at the University of Virginia, told a group of school children that she "loved to talk to books." She recited a list of classics like *Treasure Island, King Arthur, Kidnapped,* and *Robinson Crusoe.* "Those books contained within them worlds within worlds. They were windows of the imagination."

The late Ray Bradbury, writer of short stories, film maker, playwright, screen writer, and one of America's greatest raconteurs, came to San Diego, California, and encouraged his audience of writers (including me) and would-be writers to go to the library. Live in the library. Go and fall in love. Love authors like Jules Verne, Herman Melville, Rudyard Kipling, Thomas Wolfe, Emily Dickinson, Ernest Hemingway, and F. Scott Fitzgerald. Make your own list but read good literature, not what is on the best seller list. Go to the library and read about your senses, he said. Read about your eyes. Read about your ears. Collect metaphors. All of this reading will help you develop your own metaphors. Study Haiku; it is all metaphor. Mr. Bradbury said the Old Testament and Shakespeare "were his midwives." They birthed him in metaphor. "Remember," he said, "you collect things intuitively not intellectually." His audience was advised to "remember when you were a child, eleven, twelve, or fifteen, and a good book would transport you into another world and you ran and told everybody you knew that they had to read this book?" His advice? Never lose that enthusiasm.

"The one thing we seek with insatiable desire," wrote Emerson, "is to forget ourselves, to be surprised out of propriety, to lose our

sempiternal [having neither beginning nor end; eternal] memory, and to do something without knowing how or why…. Nothing great was ever achieved without enthusiasm."

Continue to fall in love with great authors and great books. We are never going to know the secret of life. Darwin, the Old Testament, the Koran, the Creationists, take a little from each. The important thing is to get on with "the elation of living." Witness and celebrate life. Take a chance. Make a difference.

Reading and writing are like taking in the wonders of the world and handing them back out again. If a book is going to be successful, it will stimulate the reader emotionally. And if the writing is going to be successful, it too will stimulate the writer emotionally. Writing is not only a form of communication; it is an affirmation. Let the reader identify with and contemplate what others have generously communicated. What others did when they wrote was what you will do when you write; that is, you will identify yourself. You will confirm, endorse, assert, approve and condone your reflections, observations, and conclusions. For the writer, it is the act of writing itself that helps heal wounds, identify personal philosophies, and leads to an understanding of his or her place in the universe. To the religious, it is a spiritual journey.

> *"When power leads a man towards arrogance, poetry reminds him of his limitations. When power narrows the arena of man's concern, poetry reminds him of the richness and diversity of his existence."*
>
> John F. Kennedy

Poetry and creative writing differ from all other artistic forms. They explain fresh ways of feeling. "The first thing for a writer to learn is the art of transposing what he feels into what he wants to make others feel."

(Albert Camus) Consider poetry as the language in which we explore amazement. John Milton, English poet of the seventeenth century, said much of his best poetry came to him in dreams. Late in life, he said he came to realize that God needed not his head nor his intellect, but his heart to inspire creativity. According to Joseph Campbell, myths and dreams come from the same place.

Returning to words, remember the etymology of courage is *coeur,* a French word meaning heart. And yes, it does take courage to admit we do not have the answers. But be honest with yourself. Acknowledge what you do not know and enjoy the journey called *discovery.*

> *The historian relates the events which have happened, the poet*
> *those which might happen.*
>
> Aristotle

Art of any kind brings order out of chaos. It finds meaning in all aspects of life including terror, sex, beauty, and war. It could be said that art undresses the world. The poet and creative writer act as a window or mirror and often speak to the reader subliminally (*limin*, Latin, 'the threshold'). Learn to recognize the symbiotic relationships between art and the life of the spirit. The act of writing creatively allows and assists us to experience perceptual and emotional growth. Jacques Maritain, the French Neo-Thomistic philosopher, stated, "I ... point out the benefits men receive from poetry. Though in themselves of no help to the attainment of eternal life, art and poetry are more necessary than bread to the human race. They fit it for the life of the spirit."

> *Be patient with all that is unsolved in your heart and try to love*
> *the questions themselves.... Do not seek the answers which cannot*
> *be given you because you would not be able to live them. And the*
> *point is, to live everything. Live the questions, now. Perhaps you*

will then gradually, without noticing it, live along some distant day into the answer.

<div align="right">Rainer Maria Rilke, poet, 1875–1926</div>

Also consider the message of Wei T'ai:

Poetry presents the thing in order to convey the feeling. It should be precise about the thing and reticent about the feeling, for as soon as the mind responds and connects with the thing the feeling shows in words; this is how poetry enters deeply in us. If the poet presents directly feelings which overwhelm him and keeps nothing back to linger as an aftertaste, he stirs us superficially; he cannot start the hands and feet involuntarily waving and tapping in time, far less strengthen morality and refine culture, set heaven and earth in motion and call up the spirits.

This was written in the eleventh century! Now it is your turn.

16

Summary

Creativity "is one of those hypnotic words which are prone
to cast a spell upon our understanding and dissolve our
thinking into haze. And out of this nebulous state of the
intellect springs a strange but widely prevalent idea. The
shaping spirit of the imagination sits aloof, like God ...
creating in some thaumaturgic fashion out of nothing its
visionary world.... The ways of creation are wrapt in mys-
tery; we may only marvel, and bow our head."

Albert Einstein

In his Nobel Prize address, William Faulkner said he believed a writer must deal with "the problems of the human heart in conflict with itself ... leaving no room in his workshop for anything but the old verities and truths of the heart." The key to writing is honesty. Listen to your heart first, then write from your head. The mythical patterns are intrinsic to the human soul and will evolve naturally in your writing. The aesthete (one who perceives) is in each of us if we are willing to take the time to look and listen and feel. If we do, if we stop the incessant chatter of our inner voice and let the voice of the universe enter, sensitivity and imagination and intuition will take hold and the creative muse will follow.

Man's existence is defined by thought. Thought is understood via the medium of words. One of the most common forms of communication is storytelling. The most revealing stories are myths. They reflect the very core of human attitudes, the inner domain of the human psyche, history,

ethics, religion, in sum, human thought combined with human language with at least a hint of the universal.

As we noted earlier, man is the only being who is conscious of being conscious and a writer is a being who can watch himself watching and write about it. Remember as a writer to take time, notice each thing so that each thing gets noticed. Anaïs Nin said, "We write to taste life twice." In the same vein, she also wisely wrote: "We don't see things as they are; we see them as we are."

Don't question whether to write and don't procrastinate doing it. Get on with the elation of living. Since we are never going to know the secret of life, we must take the responsibility to do what we can do, namely, witness and celebrate. Take a chance. Make a difference.

> We have reached a crossroads in human evolution where the only road which leads forward is toward a common passion.... [T]o continue to place our hopes in a social order achieved by external violence would simply amount to our giving up all hope of carrying the spirit of the Earth to its limits.

These words, written by Fr. Pierre Teilhard de Chardin, come back again and again to haunt me. They were written after he had experienced the horrors of World War I. Already ordained, he nevertheless volunteered to be a stretcher bearer. Today, as I read the papers, watch the television news, and hear about similar events on the radio, it seems for every two steps we take forward, we slip back one (sometimes visa versa!). Samuel Johnson (1709–1784) wrote: "It is the writer's duty to make the world better." To accomplish this, it is my opinion that three aspects of the human psyche need to be developed, namely: imagination, inspiration, and creativity.

Summary

I was as a gem concealed;
Me my burning ray revealed

from the Koran

Consciousness, including enthusiasm, inspiration, and creativity does not come from the brain. The brain is simply an organ. It focuses and draws consciousness in and directs it out. But the source of consciousness is the universal consciousness of which we as individuals are only a part. We must never give up the love of wonder which lives in every human heart nor the child-like appetite, amazement and joy for everything that is new. Dr. Seuss warned, *"If you don't get imagination as a child, you probably never will."* And as Douglas MacArthur advised: *"Years may wrinkle the skin, but to give up enthusiasm wrinkles the soul."*

The creative arts are part of consciousness. The creativity aspect of that consciousness draws upon a part of our thought process that cannot be explained rationally. Passion cannot be explained rationally. Think of all the energy it takes to fight and argue as if winning were the cure. However, the passion to which I am referring is not anger. No, the passion I refer to is the result of an intoxication with life. It is the wonder and delight we feel if we just take the time to look and see, to listen and hear.

This is a poem I wrote to explain my concept of creativity:

CREATIVITY
Planetary progress is being made,
So-called progress called technology.
But there is another path toward progress:
Creativity, the caring core of psychology.
Creativity cannot be ignored
Nor can it be disguised.

Become beguiled by your subconscious,
It cannot be contrived.
For every creative endeavor,
There is a spiritual side
Since the source of inspiration
Can never be denied.

Let thoughts flow as a current of compassion,
Believe the unbelievable, accept with satisfaction.
Yet creative imagination is but a part,
Since all intuitive collections come
From a place deep inside: the heart.
(This poem is not a prop
To design a new creation.
This poem presents a passage
For your dedication.
Drop inhibition; do not forestall,
Let the creative muse come to call.
Yes, she who lurks, who waits within us all).

As Robert Frost said, writing a poem is "never a thought to begin with…. A poem begins with a lump in the throat … a home-sickness or a love-sickness…. A complete poem is one where an emotion has found its thought and the thought has found the words…."

For the artist, there is a clarity and an order in the beauty of nature. Our participation in and with nature allows us to recognize that fact. According to the (assumed) Rossicrucian Michael Sendivogtus (1566–1636), "This natural world is only an image and material copy of a heavenly and spiritual pattern…. Thus the sage sees heaven reflected in Nature as in a mirror, and he pursues this Art, not for the sake of gold

or silver, but for the love of the knowledge which it reveals." So even the inexperienced, the so-called 'amateur' can gain insight just taking the time to observe nature.

> *Our observation of nature must be diligent, our reflection profound,*
> *and our experience exact. We rarely see these three means combined,*
> *and for this reason, creative geniuses are not common.*
>
> Denis Diderot, 'On the Interpretation of Nature'

And, back to words, did you know the Latin root of the word *amateur* is the verb *amare* meaning "to love?"

The writer must allow imagination to wander and then reshape the images into something new. The more cognitive we get as a society, the further removed we become from the intuitive experience. We must remember, we do not exist in this world isolated. We are not only social beings, we are part of the very nature which surrounds us. We shape the world and the world shapes us.

> *The secret of artistic creation and the effectiveness of art is to be found*
> *in a return to the state of 'participation mystique' – to that level of*
> *experience at which it is man who lives, and not the individual.*
>
> Carl Jung

Perhaps, as Carl Jung and Teilhard de Chardin and so many others have suggested, the actual fate of the world will grow out of what happens in the minds of men. Man, Rudolf Steiner states in his philosophy of education, is gifted with a soul and is here to give the spirit a dwelling place:

> *I look into the world in which the sun is shining, in which the stars*
> *are sparkling, in which the stones repose ... I look into the soul that*

lives within my being: the world-creator moves in sunlight and in soul-light, in wide world space without, in soul – depths within. Oh, beauty, ever ancient and ever new.

St. Augustine

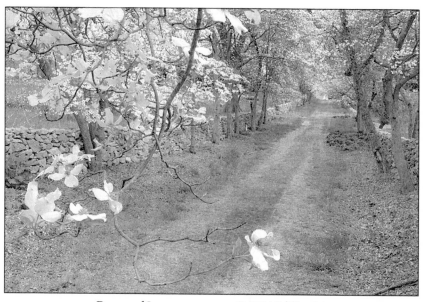

Dogwood Lane © *2004 Ed Knepley*
http://www.pbase.cm/ed_k

I hope this little book has touched the creative muse lurking inside of you, tickled your fancy, and wet your appetite. It is not necessary to put the pressure of publication as a goal; far better, and more fun, is to write for the sake of writing. Remember, it is the process not the product. As Phyllis Whitney said, learn to "think with a pencil." What comes out on paper may be the most wonderful gift you have ever received and, just think, you gave it to yourself!

Remember man is both creature and creator. Creative energy creates. The journey never ends. My final quote is from Sendivogius, philosopher and chemist of the 17th century:

Summary

There is no greater help towards a successful end than a good beginning.

And yes, it is my hope to have inspired you, the reader, to begin and become the writer using myth, magic, and metaphor to stimulate your creative minds and allow your authentic self to blossom.

Postscript

*N*ow on a personal level, let me share some of my experiences. Not always writing, part of my life has been immersed in art. In the mid 1990s, when I was asked to exhibit all my paintings and drawings at one time in one place, this is what I wrote:

Maybe I am a late bloomer. Maybe it just took me a long time and lots of exposure, but I have finally arrived at an important juncture in my life. What I used to consider a pastime, I now consider a passion. Two creative arts, painting and writing, have become a focus in my life. I crept into taking my art seriously, slowly and methodically. I watched as my father painted when I was a child. One year, we actually moved to Mexico so my father could take time from work and concentrate on his painting. I learned to use watercolors when a woman down the street from my home in La Jolla, California, opened her house to the children of the neighborhood on Saturday mornings and taught watercolor painting. Often we would take our tablets down to the rocks beside the beach and attempt to paint the incoming surf. My affinity to the Pacific Ocean probably comes from that period of my life. Later I attended the local (La Jolla) Art Center's children's art classes in a little white wooden building with trellises laced with flowering Wisteria vines in front.

I won some little shows, but, for me, art was just a pleasant thing to do. Although I always took art classes in school and

later at Vassar College, it still was not enough of a passion
to warrant full-time study. As a young adult, I studied figure
drawing at the Corcoran Art Gallery in Washington, D.C.
and portrait painting in New Jersey on Long Beach Island.
My likenesses were quite good but the paintings lacked
depth (or was it maturity?). They were more like caricatures
or illustrations. What is it about a painting that defines it
as great? (I am thinking about Matisse's ladies. Their faces
are not anatomically correct. Their features are rendered
with simple squiggles and lines and blotches of paint and
yet they are so expressive). I came to find that between
years of learning to draw figures with proper proportions
and dimensions, tones, and contrasts, and learning to paint
with style, my own style, there exists a leap of faith. It takes
knowing how to draw things and people as they really are to
be able to draw or paint them as they appear to you the artist.
And further, it takes knowing who you are to be able to relate
to the model. There is nothing shy about most artists. A good
example is Picasso. Knowing who you are, being secure in
your own person is essential to relating to your model and
painting with compassion. In the so-called modern period ·
of art history, beginning with the Impressionists, I believe
emotion comes through no matter what or who the subject is.
Art has become more than a craft, a technique; it has become
one of man or woman's most wonderful expressions of him or
herself. My paintings and the paintings I enjoy most are the
antithesis of taste and design. "Taste is not a creative faculty."
(Hans Hofmann, 1952) An artist must surpass the limitations
of calculations and construction. "Painting rises out of the
volcanic center of the artist's temperament." (Ibid)

After my children were grown and on their own, I began teaching part time in colleges and schools. What I taught initially were English skills: writing, grammar, poetry, short stories, and drama. Then I introduced a new course to Maryland Hall for the Creative Arts: Myth, Magic, and Metaphor [the birth of this book]. Here I am finally ready to fully commit myself to the creative arts, and to inspire others to experience the radiance both within nature and within themselves through art.

[In the mid 1990s] I had a one-woman show at the Thomas Jefferson Unitarian Universalist Church in Charlottesville, Virginia. Many of my paintings had been exhibited and sold in Annapolis and several were for sale in a Gallery in Washington, DC. But this was to be a kind of overview of my work from the past ten years. I gathered whatever paintings I could find and attempted to group them. Hanging a show requires a tremendous amount of planning. Each wall can take only so many paintings. Next to doorways maybe only one or two paintings can be hung. In the hallway, a whole lineup is possible. What conditions should I impose on the groupings of paintings? With amazement, I realized that a chronological theme would not work at all. My styles varied so much as I attempted different methods and mediums. There was no consistent evolution of a style; they simply were different techniques. It was as if many different people had contributed to the exhibit. As the subjects differ, the locations differ, and my mood differs; so too the paintings differ. It was not always experimentation which caused the change in style. Often it was my experience with the subject that changed. For example, I painted two of my horses. Their faces and

bodies are anatomically correct but they are blue. The horses are flying. In the background there is something resembling the edge of the world and an endless sky. I cannot tell you why. It just happened. The horses' eyes are very expressive and I know they are my horses. Their eyes reflect the animals' personalities, their essence. There are no bridles, no reins, and the riders were almost an afterthought. The real and the unreal are combined. The painting has a dreamlike quality. Possibly the fact that I had to give them up (they were both sold by the time I painted their portrait) had something to do with the way I chose to paint them.

In another painting, I depicted the bow of our sailboat. Wind is the primary factor in sailing. In this painting, the sail, the telltale, the clouds, and the sea reflect wind power. In the horizon are the beginning traces of an imminent squall. The distant clouds are tight and dark; the sea is ominous. But on the boat the light is still coming from the sun and its brilliance is reflected in the mainsail. The clouds overhead reflect the soft pink and yellow light. The boat is still steady. This is how it is at sea. One minute you are sailing lazily along and the next minute there is a powerful shift in weather. The sails are adjusted; the boat races along on its side; and the placid sea becomes angry and powerful. Waves crash on the deck and the person at the helm hangs on for dear life. A sailor must always be on the alert. This painting portrays the immanence of change.

That was me then and, probably, your author today as well.

About the Author

*T*his book was originally written as the result of teaching/ facilitating/encouraging/inspiring students to write and to write creatively. Patricia Daly-Lipe originally created the course at Maryland Hall for the Creative Arts in Annapolis, Maryland, and went on to teach at colleges, universities and writing centers in Maryland, Virginia, and California. Some of this text was also used as part of her doctoral dissertation.

Dr. Daly-Lipe has also combined a collection of short stories published in various magazines over the years along with some of her poems and a story by her father into a book called *Messages from Nature* (originally *Nature's Wisdom*). In the year 2000, as a result of writing a series of weekly articles for *La Jolla Village News* celebrating the millennium, Daly-Lipe was asked to write a book bringing together those articles for Sunbelt Publications. The result, *La Jolla, A Celebration of Its Past,* won the 2002 San Diego Book Awards. In 2004, after fourteen years of research, her first historical fiction was published. *Forbidden Loves, Paris Between the Wars.* The story takes place 1927–1939 and explores a fascinating era of innovation on all levels, from Lindbergh to James Joyce, from Picasso to Joseph Campbell, and offers a glimpse at the glitz that was Paris between the wars while depicting aviation history in the making, the American exile community, modern art, Hannibal, the Catholic church and a moving love story. The book was reissued in 2010 as *A Cruel Calm, Paris Between the Wars* and received first Prize for Historical Fiction in 2013 from the Royal Dragonfly Book Award. It is was reissued again in 2015 and is now being considered for a movie.

Two other books followed. A memoir, *All Alone, Washington to Rome* and the biography of her great uncle who volunteered to serve the troops in WWI, *Patriot Priest, The Story of Monsignor William A. Hemmick, The Vatican's First American Canon.* And, in 2014, *Helen Holt, Memoir of a Servant Leader* published by the Pen Women Press, of the National League of American Pen Women, Inc., an organization in which Dr. Daly-Lipe served as President of two branches: La Jolla and Washington, DC.

Dr. Daly-Lipe encourages you to stay in touch. Go to: http://www.literarylady.com and check for her latest events and presentations. She may be in your area sometime soon and would love to meet you.

CPSIA information can be obtained at www.ICGtesting.com
Printed in the USA
BVOW02s0614230916

463063BV00003B/3/P